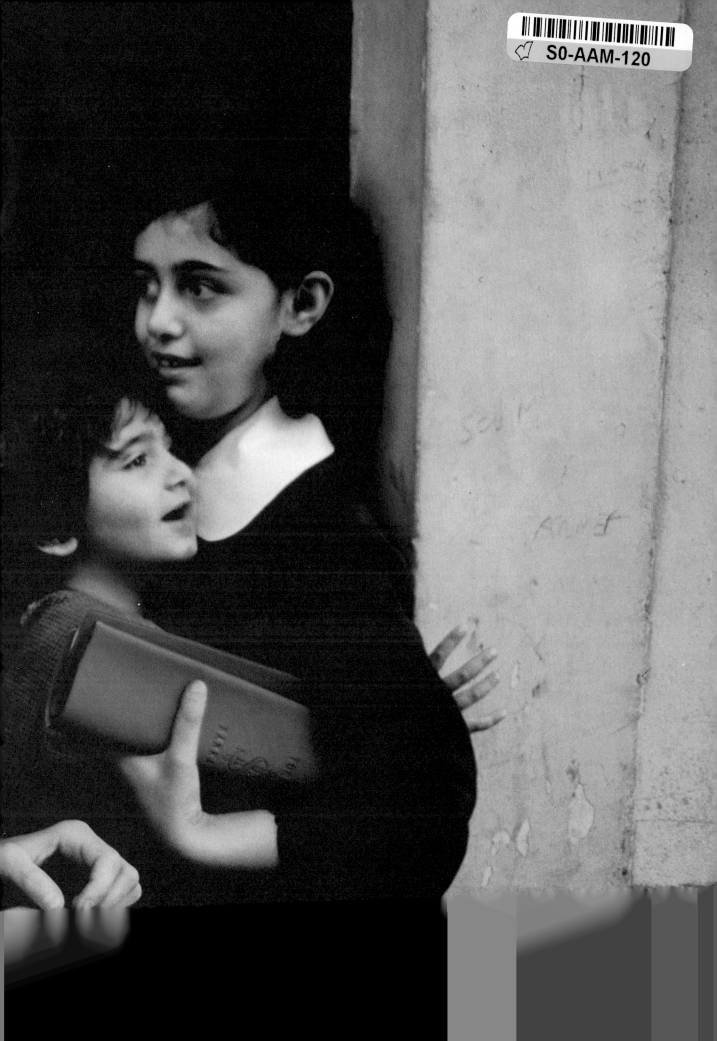

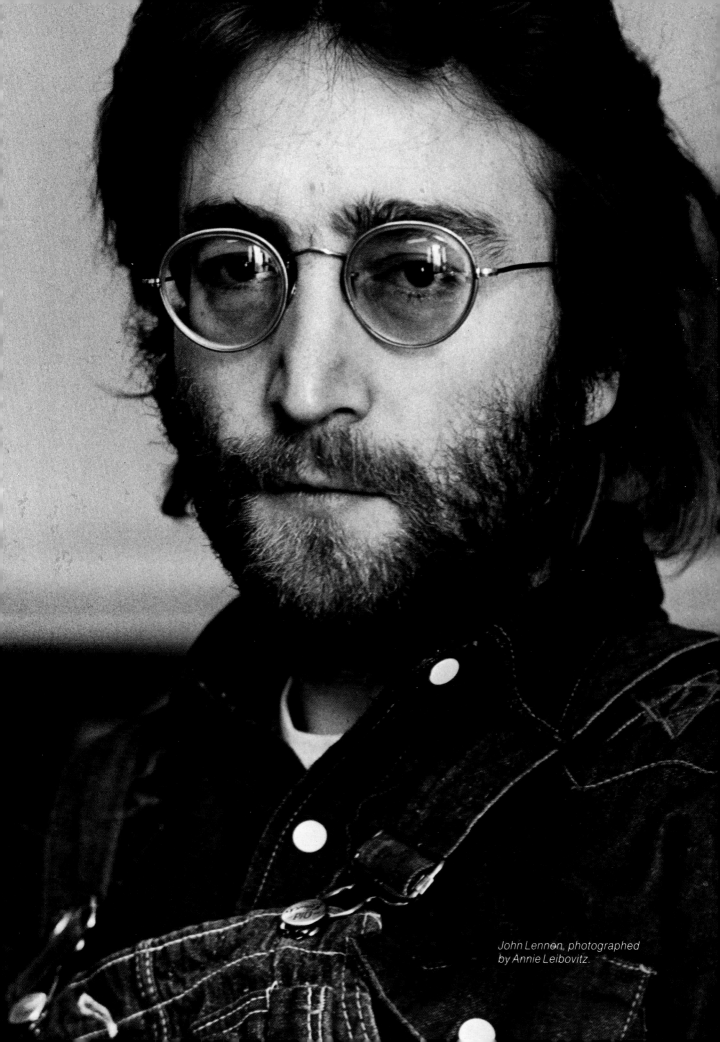

John Lennon, photographed
by Annie Leibovitz.

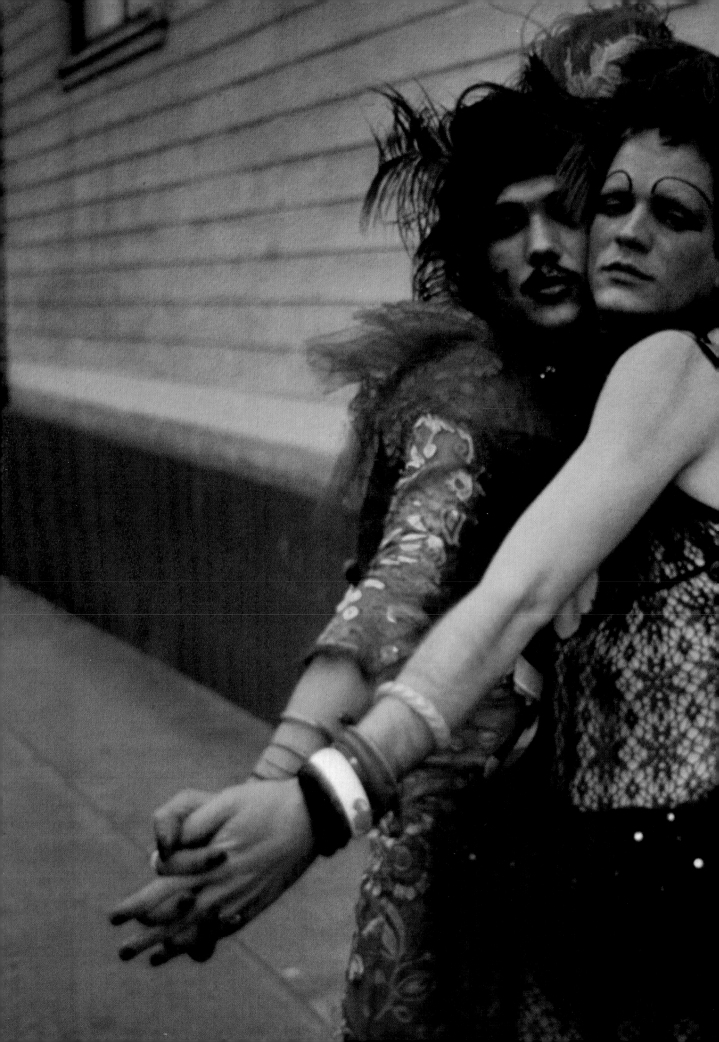

the Photojournalist: Mary Ellen Mark & Annie Leibovitz

text by Adrianne Marcus
with the editors of Alskog, Inc.

Introduction... 8
Surface and Depth: Two Women.................................12
Annie Leibovitz: One Frame at a Time16
 Photographing Folk Heroes as Folk Heroes...........17
 Documenting the Counterculture28
 Interpreting Personality Through Portraits.............38
Mary Ellen Mark: Using the Camera to Explore
 Spaces Between People......................................56
 Summing Up Current Events.............................64
 Reporting Intimate Dramas72
 Discovering Social Change83
Technical Section..89

An Alskog Book
published with
Thomas Y. Crowell Company, Inc.

Prepared by Alskog, Inc.
Lawrence Schiller/Publisher
William Hopkins/Design Director
John Poppy/Executive Editor
Vincent Tajiri/Editorial Director
Julie Asher/Design Assistant
Arthur Gubernick/Production Consultant
Jim Cornfield/Technical Consultant

Library of Congress Catalog Card Number: 74-8229
ISBN: 0-690-00620-9 Soft cover
ISBN: 0-690-00619-5 Hard cover
First Printing
Published simultaneously in Canada
Printed in the United States of America

Entertainers in San Francisco, photographed by Mary Ellen Mark "not for camp, but for tenderness."

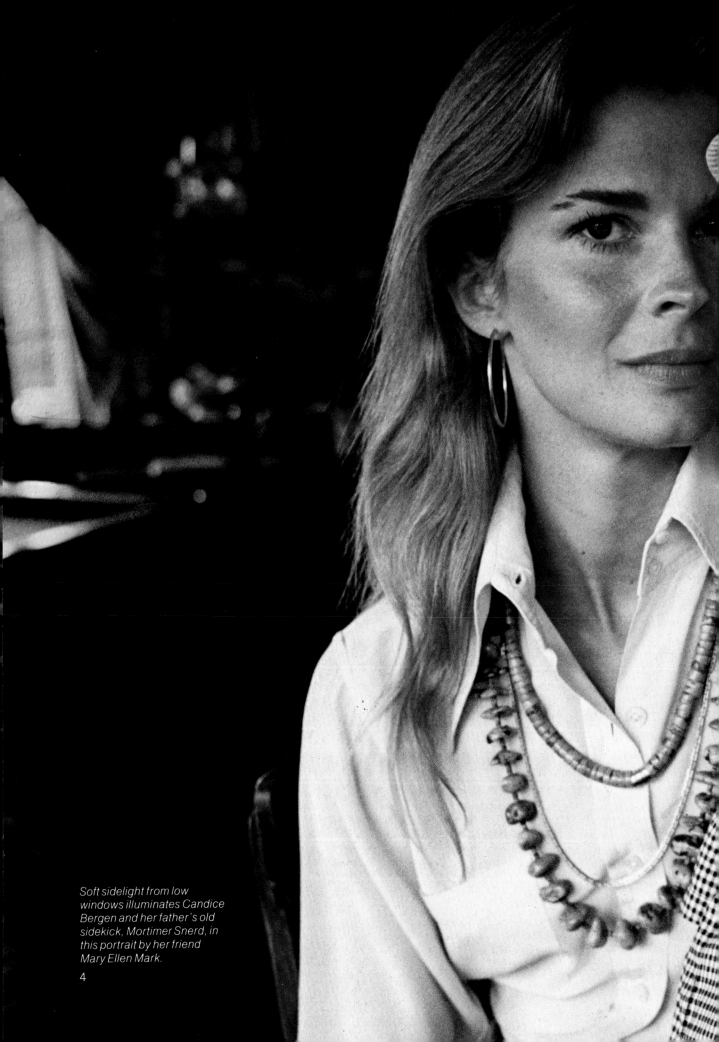

Soft sidelight from low windows illuminates Candice Bergen and her father's old sidekick, Mortimer Snerd, in this portrait by her friend Mary Ellen Mark.

4

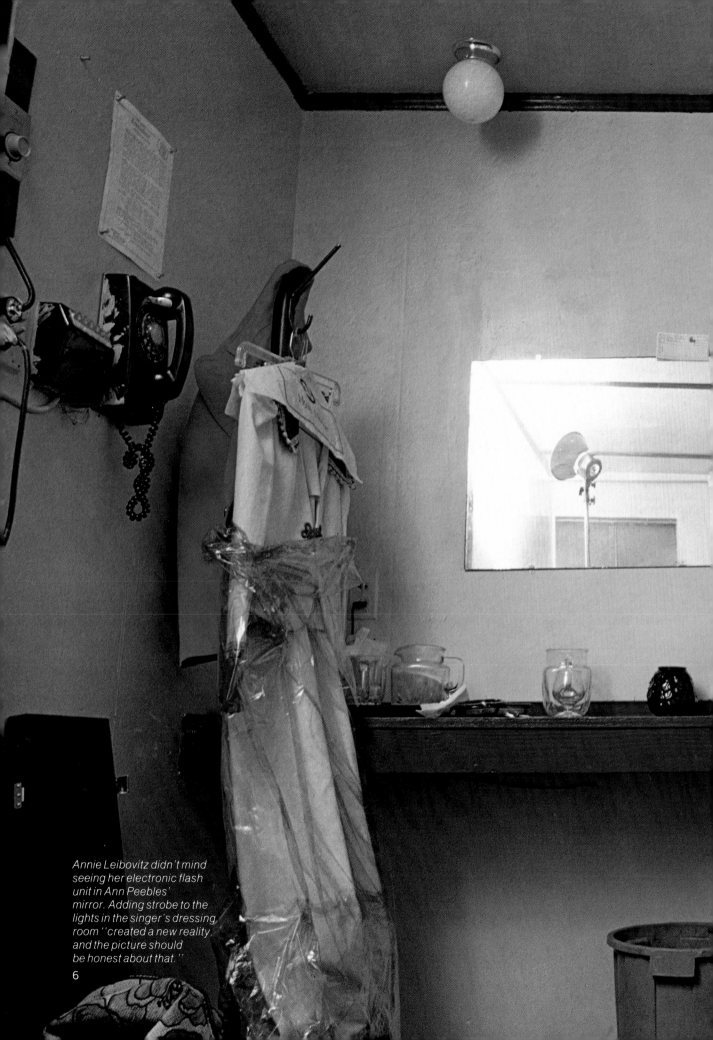

Annie Leibovitz didn't mind
seeing her electronic flash
unit in Ann Peebles'
mirror. Adding strobe to the
lights in the singer's dressing
room ''created a new reality,
and the picture should
be honest about that.''

6

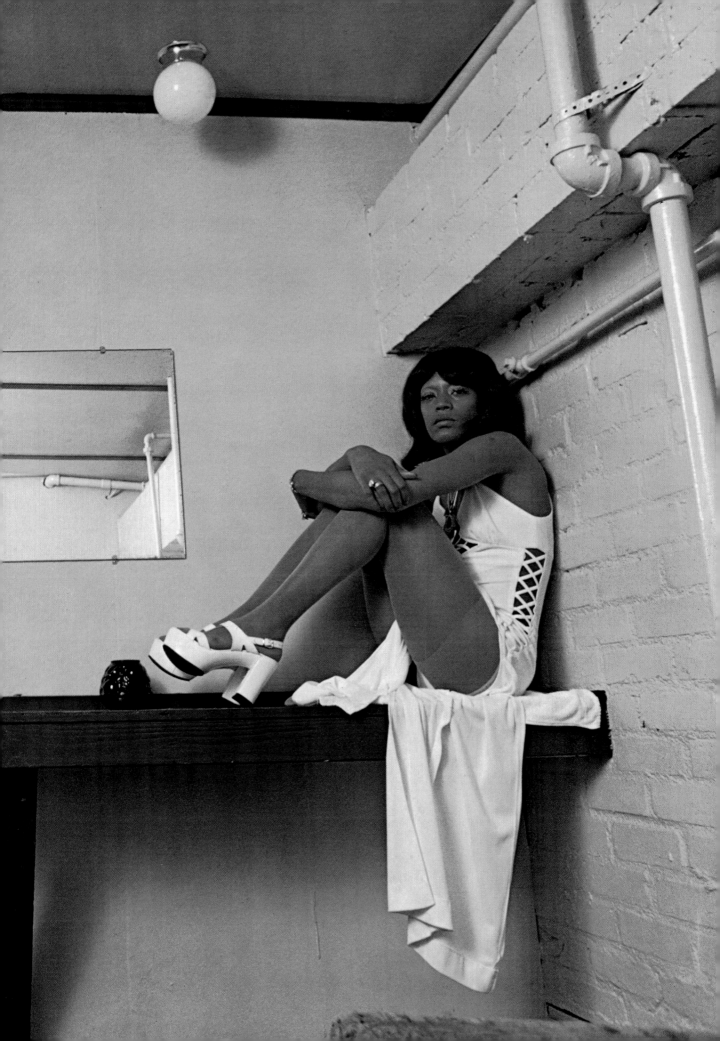

Introduction

As long ago as 1855, wet-plate photographs thrust a first-hand view of the Crimean War into comfortable Victorian parlors. In this century, the power of a reporter with a camera to sum up both news and broad social change has grown so dramatically that photojournalists now speak to us at every turn through channels as diverse as newspapers, magazines, book jackets, corporate annual reports and television.

Of all the types of photography—including illustration, essays, portraits, studies of the human figure in action, private statements by professionals—photojournalism owes its broad reach to our hunger for believable reporting of events we would not ordinarily see.

The pursuit of such images began as a man's business. But W. Eugene Smith, one of the most respected of all photographers, said as we discussed this book, "I can think of three or four young Americans whose pictures really move me, and they are all women. Women seem as determined today to push hard and make fine pictures as men were in the Forties when they were trying to get to *Life*." And a photojournalist does need determination. Working every day in the tradition

This pungent Annie Leibovitz study of rock star Rod Stewart became a Rolling Stone poster.

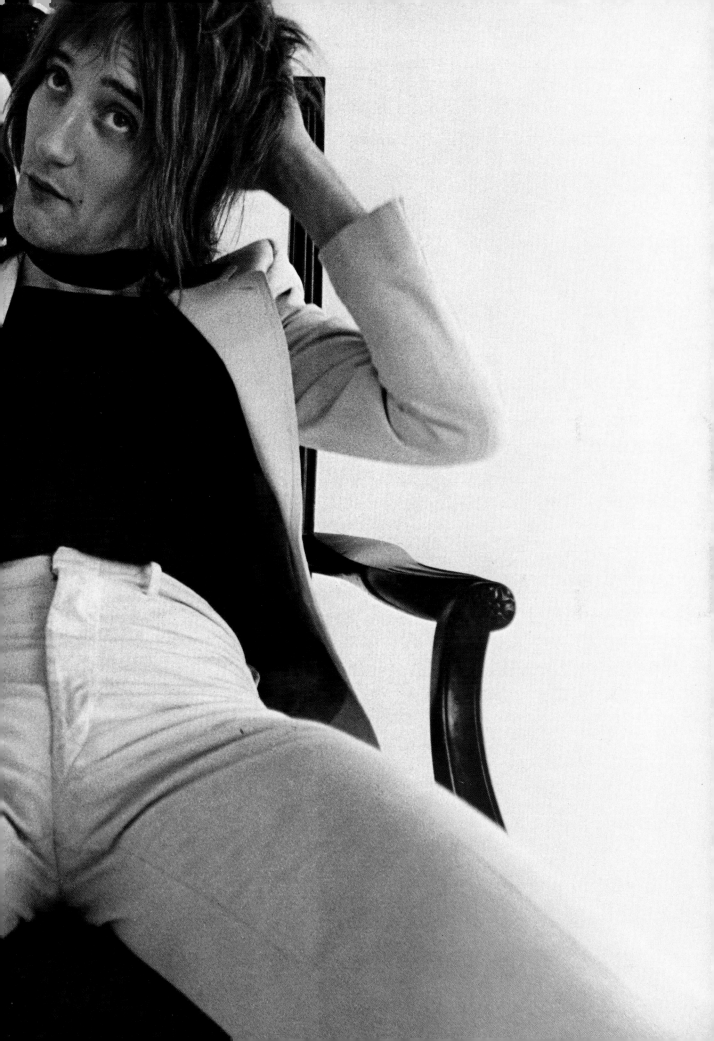

of great reporters such as Smith, Alfred Eisenstaedt, Margaret Bourke-White, Eddie Adams, Flip Schulke, Bill Eppridge and hundreds of others, called on to photograph any person and any event that comes along, a photojournalist needs both the imagination to compose a striking picture and the stamina to outrun a crowd of other photographers going after the same subject.

It comes as no surprise, then, that two of the most influential photojournalists working today are Annie Leibovitz and Mary Ellen Mark.

Annie Leibovitz makes most of her pictures for the combination newspaper / magazine *Rolling Stone,* a leader in the fast, young brand of journalism that has succeeded the *Look*s and *Life*s. She runs at a pace close to that of a daily news photographer, dashing from city to city to pursue political figures, pop-music stars and counterculture personalities whose lives affect many others.

Mary Ellen Mark bridges the gap between the old mass-circulation picture magazines like *Look,* where she was first published, and the more pointed contemporary style of one like *Ms.* She roams worldwide to cover international crises including two civil wars, but can also range into the birth of a baby or the world of a WAC.

Neither woman limits her pictures to one market. Mary Ellen Mark's appear in places as diverse as *Ms., Esquire, Paris-Match, Time* and *Newsweek.* Annie Leibovitz's photographs reach beyond *Rolling Stone* to *Ms., Esquire,* and *Vogue,* which has asked for her not as a fashion photographer but as a photojournalist.

Mary Ellen Mark photographed singer Arlo Guthrie washed by the light of stained glass.

Surface and depth: Two women

New York: "Hey, lady! Where do you want this stuff?" the cab driver growled, gathering up an odd assortment of baggage, thinking of the other fares he had passed up for this lanky woman in jeans and crumpled velvet blazer. "Christ," he thought, "she must be six feet tall." Annie Leibovitz did several things simultaneously: glared at the driver while fumbling for his fare, made sure she hadn't left a camera or a lens in the back seat, and looked for the stage entrance to Madison Square Garden, mentally preparing herself for the scrimmage ahead. Thirty or so photographers, 20,000 rock and roll fans, everyone focused on one thing: the Rolling Stones. She clutched her cameras as the roar of traffic subsided into the wilder roar of the arena. This was her playing field, and the Stones her ball game. She shook her head as another photographer yelled, "Hi, Annie! Need any help?" Inside, she would have to outmaneuver him

Belfast: An ocean away, Mary Ellen Mark tried to blend into a crowd of militant Protestants while this corner of Northern Ireland paused for a moment of uneasy peace. Other photographers had made their pictures of the rally and left, but she had stayed on, watching the crowd disperse, looking for yet another way to capture the metabolism of violence in a civil war for *Ms.* magazine. The hooded men seemed to be staring at her when she walked by; she wondered if she shouldn't have left earlier. What was registering on those faces behind the masks? Hostility? Would they take her film away? "No," she thought, "I can't leave until I get the picture I want." She pretended assurance

Salinas: Annie Leibovitz drove through a grey California rain, wondering how she was going to keep her cameras dry, and obtain contrast in the flat, uniform light, and record the emotional reactions of prisoners who had been given this one day with their families at Soledad Prison. "Maybe I'll be the only photographer there," she consoled herself, "and I'll see what's happening without it being distorted by a bunch of others running around snapping photographs"

Los Angeles: Mary Ellen Mark checked her light meter while suggesting to her friend Candice Bergen that light from the side windows would really be more flattering. As Bergen sat down, holding a Mortimer Snerd doll, Mary Ellen toyed with a thought. "What if I move in even closer, open it wider and fill the frame this way?" She looked through the viewfinder. Was the darkness behind Bergen slightly suggestive of the absent member of this trio, Bergen's father, Edgar, the ventriloquist who had used Mortimer Snerd in his act? Sometimes what wasn't in

Annie Leibovitz with one of her two traveling strobeheads and an umbrella, photographed by Ethan Russell.

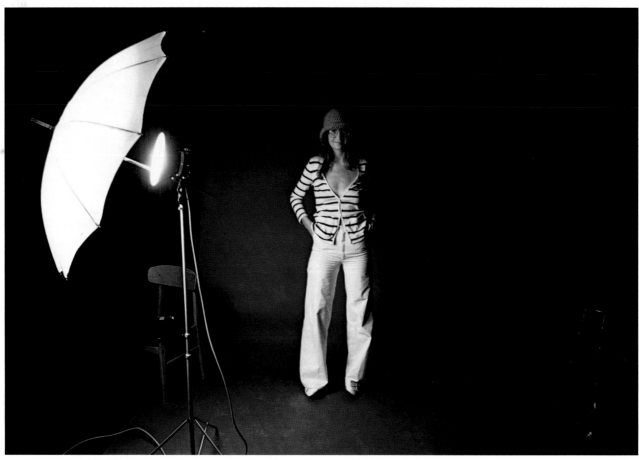

the portrait could be deliberately suggested by arranging what was. ''Move the doll up closer to your face, Candy. That's really nice''

Photojournalism **is a chase.** Stalking the personality of an individual or a news event, a photojournalist hunts for the picture that sums it all up. The chase means almost constant motion: wherever an event, personal or public, is happening, the photojournalist must be there, prepared with film and equipment for any condition or change, to record a moment that will never occur again. A writer may rewrite, an artist repaint, but once her quarry has moved out of range, a photojournalist cannot make a picture happen again. She must evaluate everything in a situation, narrow it down to the size of her frame, and choose what Henri Cartier-Bresson calls ''the decisive moment.'' The decisive moment of action is what matters, and jostling other photographers, competing for a better picture of the same event, adjusting to weather, airplane schedules, obstinate subjects and outright hostility are all part of it. Determination and an ability to change constantly in changing conditions are requirements for a hunter, a photojournalist.

For two women in a predominantly male field, Annie Leibovitz and Mary Ellen Mark, the chase is an entire life. What drives

them drives all creatively obsessed people: a need to look, to see, to show and to know even in a moment of triumph that there is something else ahead you haven't seen and haven't captured—yet.

There have been relatively few women photojournalists, but among them there are pioneers who opened paths for photographers of both sexes. The list includes Berenice Abbott, Eve Arnold, Charlotte Brooks, Inge Morath, Barbara

Morgan and, of course, Dorothea Lange and Margaret Bourke-White.

Dorothea Lange took her camera and moved across the landscape of America, finding the lives of the dispossessed in the dust bowl of Oklahoma. She followed them in their rickety cars as they tried to escape into an unknown future. While the country reeled in economic instability, she sharpened the Depression down to a human tragedy. This small woman with her Rolleiflex

Mary Ellen Mark,
by Nancy Ellison.

recorded the faces around her with compassion and understanding, the anonymous faces she had tracked down—made them the statement of a human condition, just as Margaret Bourke-White began by going into the mills, the heart of industry, to record another aspect of America. Wrenched from her career in industrial and advertising photography by the suffering she recorded

in the Great Drought of 1934, Bourke-White moved more and more into humans as subjects for her big 4x5 and 5x7 cameras; she went wherever there was action, for *Fortune* and then as one of the four original *Life* photographers, whether in a bomber photographing a World War II raid, or in India watching Mohandas Gandhi at his spinning wheel. She interviewed him only hours before his assassination, then remained to photograph his thousands of mourners.

When the 35mm camera came of age, many of the new photojournalists discarded their heavy Speed Graphics and Graflexes for the lighter, more versatile cameras that could take pictures almost unnoticeably under almost any conditions. Mary Ellen Mark and Annie Leibovitz carry on the chase with these smaller but no less accurate weapons, using 35mm to the exclusion of all other camera sizes.

The Leica camera had originally been designed by Oskar Barnack, a microscope maker in the German optical works of E. Leitz, just before World War I, to test 35mm motion picture film. When an improved model appeared at the Leipzig Fair in 1925, it had a fast focal-plane shutter and a selection of quality lenses that could be interchanged. Two advantages were apparent; the camera was compact and its 36-exposure rolls of film captured fairly fine details in a negative just 1½ inches wide that could then be enlarged. Barnack's "small negative, large picture" concept would revolutionize photojournalism. Later models coupled a rangefinder to the lens so that a photographer could focus by simply moving the lens until a double image in the rangefinder sharpened into one. The

system is still the most useful one for a photojournalist working in low-light situations where other viewing systems dim out and make fast focusing difficult.

Mary Ellen Mark prefers a Leica over her other cameras. Part of her reason is professional; she likes the fact that it is quieter than a single-lens reflex, whose mirror makes an audible "clunk" when the shutter is released. But another part of the reason must go back to 1964 when, after majoring in painting for her first four years of college, she returned to graduate school. At Annenberg School of Communications, part of the University of Pennsylvania, Mary Ellen made a last-minute decision to take photography. An instructor led her over to a cabinet filled with cameras, and as she picked up a Leica, it seemed to nestle in her hand; all the clichés of finding one's place, the shock of recognition, occurred on the spot. "The very first time I held that camera in my hands, I knew I'd found what I wanted to be. Instantly."

It had been a long search, and had taken her from an upper-middle class home in Philadelphia

through high school, where a photograph of her, smiling and confident in her cheerleader outfit,

showed the results of a metamorphosis from an awkward girl of 14 who wore braces to an All-American beauty complete with boyfriends hovering just outside the frame.

Her family never considered itself warm or close; whether because of that or some need for approval that followed her through college, Mary Ellen developed an ambition to be creative. As a painter she hadn't felt she was good enough. As a photographer, she knew she was. After graduate school, a Fulbright scholarship took her to Turkey for a year, photographing, and those pictures, her first published, led to an eventful meeting in a less exotic setting.

In 1968, two women found themselves working in the same place on the same day. Patricia Carbine, then a managing editor of *Look,* had returned to her alma mater, Rosemont College in Pennsylvania, for one day to help revamp the alumni publication. She watched that day's visiting photographer, Mary Ellen, move unobtrusively around the campus, managing to get into the right places without disrupting the classrooms and spontaneous conversations she wanted to photograph. Whoever this young freelance was, she knew how to move. There would be plenty of usable photographs to convey the candid insights Carbine was looking for.

By the end of the day, Carbine knew she had met a real photographer. "Let's go have a Coke," she said to Mary Ellen. "I think we've put in a good three days work in one." She told Mary Ellen to send the pictures to her, then paused. "I'm going to say something to you I don't say very often. When you're up in New York and ready to think about a transition from this kind of picture-making to journalism, I want very much to help. I hope you'll come see me."

Not long after that, Mary Ellen arrived at the *Look* office with her photographs. Paul Fusco, their top photo essayist, saw them. "I thought the best thing I could do," he recalls with a grin and a bit of hyperbole, "was to throw my camera away. She was young, but she certainly had a hell of a lot of insight."

Insight. Perception. People talking about Mary Ellen's work find themselves repeating these words over and over. Her way of seeing and photographing is both human and ironic. Her vulnerability and openness seem to transmit an awareness of the precarious balance she maintains with people, and they with each other.

This slender, dark-haired woman seems as delicate as her voice, but that same voice takes on the quality of iron if her pictures are delayed or her work interfered with. Her will and fierce determination to document the human drama have placed her in such diverse settings as the civil war in Ireland, a hospital delivery room in Los Angeles, a sound stage in Hollywood.

On one such set, filming is in progress. Mary Ellen moves lightly, an assortment of cameras dangling like multiple necklaces as she photographs a Hollywood that existed 40 years ago, recreated for *The Day of*

the Locust. She catches the eye of an extra, an obese woman playing a minor character in the last scenes of the film. With quick introductions that involve mainly listening, she asks the extra to come outside and have her picture taken. The woman cocks her head, weighing the possibilities, and launches into an explanation of why she is unable to reduce. Outside, Mary Ellen suggests where to stand. They talk about Weight Watchers, and she checks her cameras, still seeming to give full attention to what the woman is saying.

After a few shots, Mary Ellen mentions that the light might be more flattering over by some old cars.

"Can we try it here?" She gently guides the woman into place.

"How do you want me to look?"

"You look just fine; that's great," and her camera clicks away. "Perfect." She moves rapidly forward, focusing on the woman's face,

making an active collaboration occur. "Why don't you just take off your coat?" The woman smiles, and Mary Ellen catches the moment. Slowly, steadily, they move together, the woman looking off in the distance, perhaps visualizing her perfect face, caught with the appropriate expression of thought.

Mary **Ellen backs off, crouching, framing the woman above her as the camera registers the beginning of what she is looking for.** There is no resistance; the woman's face alters, opens itself to the camera as she seems to forget that Mary Ellen is there until it is hard to

remember which one is the photographer and which one the subject. They merge, then separate.

The people Mary Ellen photographs are usually anonymous; they tell us something about the way she sees the world and the delicate irony of her perspective. How much of a woman's perspective is determined by the way society is structured against her? As she defines herself in a field that has traditionally been male, can she have what her male counterpart is automatically granted: freedom to pick up and move at a moment's notice? How does this determine how she sees herself? "I think women photographers find relationships with men difficult because photography is very isolating. I can't see how I could be with a man who wasn't somehow into photography because I live it and breathe it. I'm married to my camera; sometimes I hate it, I think it's destroying my life. I

Jack Garofalo snapped Mary Ellen Mark during a Paris-Match *assignment*

want other relationships. But my work"

For any photographer, mornings may be a series of lonely awakenings in hotel rooms, strange cities and countries, the realization that nothing is permanent except the chase. Mary Ellen brings her trophies home, and people who have shared them with her in magazines such as *Look* and *Life* now share them in other places: *Ms., Time, Newsweek, Paris-Match, Esquire.* Magazine pages, blank as walls, wait for that one picture summing up an event, recording a moment in the world around her. As Mary Ellen explores the spaces between herself and other people, hoping for approval or at least temporary understanding, she never stops looking for the next good assignment, for the trained reporter's chance to use her camera to record events as they occur, or sometimes to

make them happen. And in that moment, all the discomforts and the waiting are forgotten. Everything narrows down to a small black box held into the light, just so, the eye trained to see, as the quarry sweeps into range: the final intuitive decision, and the comforting click.

Annie Leibovitz: One frame at a time

No one ever seems to know where Annie is until she is there. Like a charter flight, she operates on estimated times of arrival.

While the chase takes Mary Ellen Mark from continent to continent, Annie Leibovitz concentrates on the United States, photographing icons of various youth cultures and countercultures.

Ten years younger than Mary Ellen Mark, Annie learned her craft on the job—as chief photographer for the San Francisco-based *Rolling Stone,* a publication that sells 400,000 copies every two weeks to a hip young audience interested in the excitement of rock and roll, irreverent political coverage and popular controversy. She has reached even broader audiences through assignments for *Vogue, Esquire, Ms.,* and appearances in news magazines such as *Time.*

Annie's pictures and photographic reputation have grown strong enough to attract stars with immense egos of their own. Her erratic concept of time is not only tolerated, but expected. After all, she is an artist dealing with artists; what better way than on their own terms?

There is nothing ordinary about her: five feet eleven inches tucked into a silver Porsche, she hurtles almost by habit between San Francisco and Los Angeles, watching the scenery fade into frame after frame. On such drives as these, past triumphs like making David Cassidy the first nude cover of *Rolling Stone* are almost forgotten. The closer she gets to Los Angeles, to today's hunt, the more nervous she becomes. To calm herself, she makes another mental check list: five lenses, the meter for the color shots, two of the three Nikons, plenty of film. Well, plenty by her standards: after all, *Rolling Stone* only needs one picture. Why waste film and time just shooting for shooting's sake?

Driving into Los Angeles, she slows down, then stops to wait for a light to change. A smile plays over her mouth as she sees a young woman, camera around her neck, crossing the street. Does she remember herself in 1968, still at the San Francisco Art Institute, convincing them to let her have a year of independent study so she could go photographing in Israel and Europe? Or in 1970, walking hesitantly into the office of *Rolling Stone,* feeling gawky and foolish, mentally cursing Christopher Springmann, the photographer friend who drove her down insisting she show them a picture she had taken and developed the day before?

The light changes, Annie shifts gears, and as the car speeds toward its

destination, she plays back a familiar sequence of events, frame by frame . . .

She had asked to see the art director. She stood

there, shifting from foot to foot, trying not to stare at the people flowing around her. A young girl with long dark hair walked by. *She's not much older than I am,* Annie realized. The print in her hand felt stiff. She wanted to crumple it up and walk out fast. *Why did I ever listen to him? They're not going to do anything but laugh.*

She looked around; everyone was well under 30 and dressed as she was, in blue jeans, bright shirts, aggressively casual. They knew they belonged here. She looked closer; they went into rooms without knocking, and she heard people laughing.

This can't be the place—Rolling Stone—*I always read it. I even had it sent to me in Europe. God, it's chaotic. How do they*

get anything done?

Half an hour later, she walked out in a daze: art director Robert Kingsbury had not only liked her picture of Allen Ginsberg, he had bought it, then thanked her for getting it there just one day after she'd taken it.

Annie Leibovitz, 20 years old, sold her first picture and got her first commercial lesson: *Rolling Stone* didn't see photography as esoteric, private art. They used it to sell papers. As she got back into Springmann's car, she mentally combined these two worlds: "I can do that work and my own, too. It's what the Art Institute says—work at the post office during the day and do your pictures at night."

What Annie walked into that day was a publication dominated by men. Their approach to women was typified by photographer Baron Wolman's photos of groupies—a bizarre assortment of women who identified themselves by the last star they had laid. The staff had no woman writers or supervisors. But it was a world Annie wanted to work in, and when she saw her picture in print, she didn't care who worked there or what they thought of women. She simply knew it was a good place for a young, ambitious photographer to be.

She continued school,

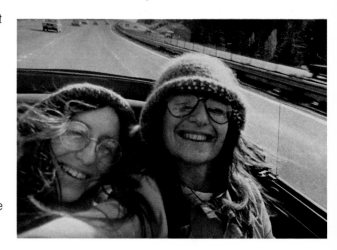

but when a chance came to gain experience as a working photographer, she applied. It would be a little different, as jobs go, involving a trip with 150 hard-core San Francisco freaks across the country and then to Europe filming a movie—just what Annie wanted. Springmann gave her a quick one-day crash course in color photography, but the sales pitch with which she beat out another photographer who wanted the job didn't mention that small fact. She understood people's doubts, and simply said, "Look. I can take better pictures than he will and do it for half the money you're planning to spend."

The sponsors of the trip bought her $2,000 worth of film, and for the next month she lived with cameras around her neck, even slipping them inside her sleeping bag. "Annie Nikon," the people on the trip called her, claiming they didn't recognize her when she took the cameras off. Experienced, she returned to *Rolling Stone* and was put on retainer for $47 a week. Security. Annie pushed harder, convinced the editors to send her to New York to photograph John Lennon as he made a movie with his wife, Yoko Ono. Again, her argument was persuasive: stay with friends, do the job cheaper, and knew *Rolling Stone*'s needs.

The pictures she returned with would soon establish her, in 1970, as an important photographer. Lennon, in contemplation, gazes beyond the camera and is mirrored somewhere between the workingclass hero of his song and Annie's larger-than-life concept of him. (Page 1.)

Annie knows she cannot just sit in her living room waiting for an assignment. She reads, she listens, she goes out and grabs subjects, then nags editors to let her make the picture.

Photographing folk heroes as folk heroes

What common challenge do John Lennon, Mick Jagger and Daniel Ellsberg offer a photojournalist? They have all been folk heroes to the young: the ways in which they live, dress and perform interest an immense public, and the details that surround them provide a framework for cultural myths.

Annie Leibovitz is part of that public; for *Rolling Stone,* her photographs must add to the the subject's image, not detract or alter. Knowing her subject has a ready audience, she must decide not only what she really sees, but what her camera is going to tell about it.

Annie had collected information about John Lennon, studied him, trying to decide what she wanted to show, where she wanted to make the photograph. She arrived early and looked around for good light. She watched him on the set, then followed him into an adjacent office. Looking for editorial pictures to illustrate an article, she began shooting with a wide-angle lens to include Lennon's surroundings. In the middle of a roll she decided to get a light-meter reading; not wanting to jar Lennon by walking over and holding a meter up to his face, she put a 105mm lens on the Nikon, framed his head carefully, and read the the camera. While she was at it, she squeezed off one exposure. Then she went back to her wide angle.

Back in San Francisco, Annie watched as *Rolling Stone* editor Jann Wenner and Robert Kingsbury went over her contact sheets. "Okay, Annie, you've got us a cover," she heard Wenner say. Looking over his shoulder, she saw him pointing to the head shot in the middle of the sheet.

"That really opened my eyes," she recalls, "to a fact I'd never thought about before—there's a special type of picture that makes a cover." The subject has to be readily recognizable but the expression has to have some little shock in it to catch the public's eye—and the composition must leave room for the magazine's name and at least one line of type. Another bit of learning, helped along by an accidental decision and a perceptive editor. A photojournalist realizes that sometimes luck plays as much a part in what happens as plans and equipment.

Technique enhances interpretation, but the eye must decide, and learning to see photographically means your equipment becomes an integral part of that process. If you don't need it, discard it.

In time, Annie gave up using a light meter for black and white: "I am confident that I can shoot anywhere with Tri-X film. I can be a stop off and it's still okay. A good printer can fix it in the darkroom." As her confidence increased, she began to experiment with light, preferring it as natural as possible. In the Lennon picture, side windows gave adequate light, but for general work she needed additional light sources.

She used a 600-watt quartz light with a C-clamp, but as her work and her needs became more sophisticated and she started using more color film, she had a special two-headed electronic flash unit designed by Norman Enterprises of Burbank, California. Her Norman strobe weighs 80 pounds, including the heavy case that protects the delicate electronic components, and it can be thrown on an airplane without risking damage. Ethan Russell's photograph of Annie on page 12 shows it in use with one head attached to a light-reflecting umbrella.

Between her picture of Lennon and those of the Rolling Stones' seventh American tour lie two years of time, technique and viewpoint.

The Stones were already the most powerful rock group of the 1970's. Wherever they played, the concert had been sold out weeks in advance, and the night of the final concert in Madison Square Garden, 20,000 frenzied fans screamed as they came onstage. Annie realized it was both a dream and a nightmare, and she was in the middle. There were fans behind her, dozens of other photographers around her, and the Stones in front of her. Almost everyone, from august literary magazines—*the New Yorker, Saturday Review of the Arts*—to the mass media like *Time* and *Newsweek,* was covering the Stones. Top rock photographers such as Ethan Russell and Jim Marshall had all been struggling for pictures that would capture the swaggering sound and presence as Mick Jagger and the Rolling Stones performed over and over again in each city. Glittering, outrageous, their high-pitched performance made arrogance and sex the dark

17

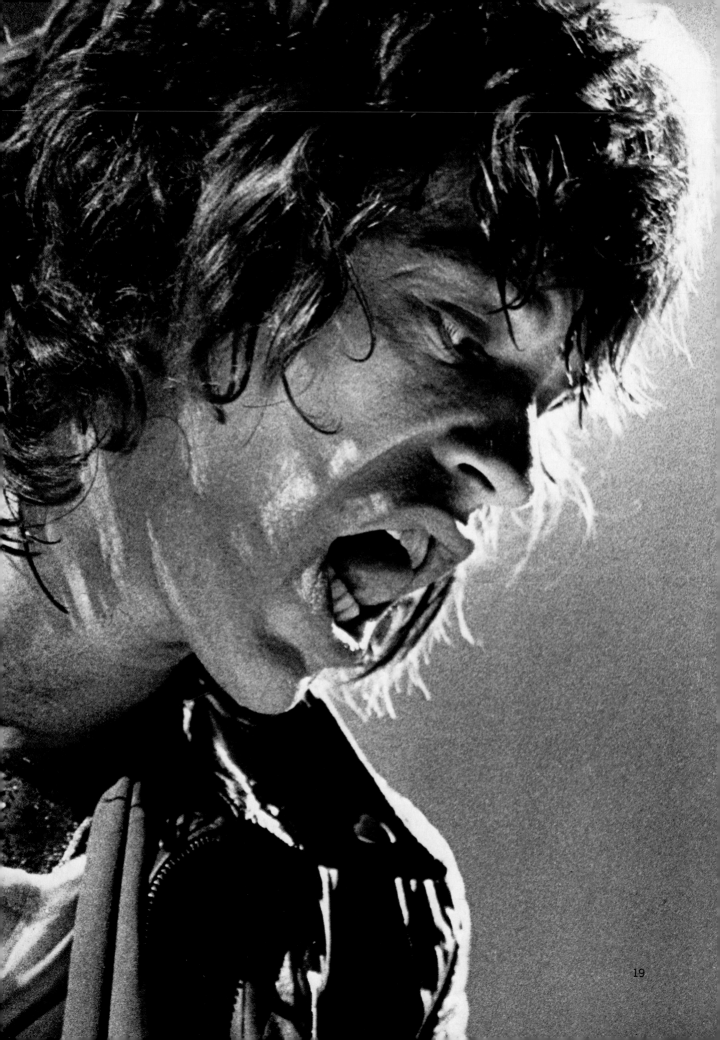

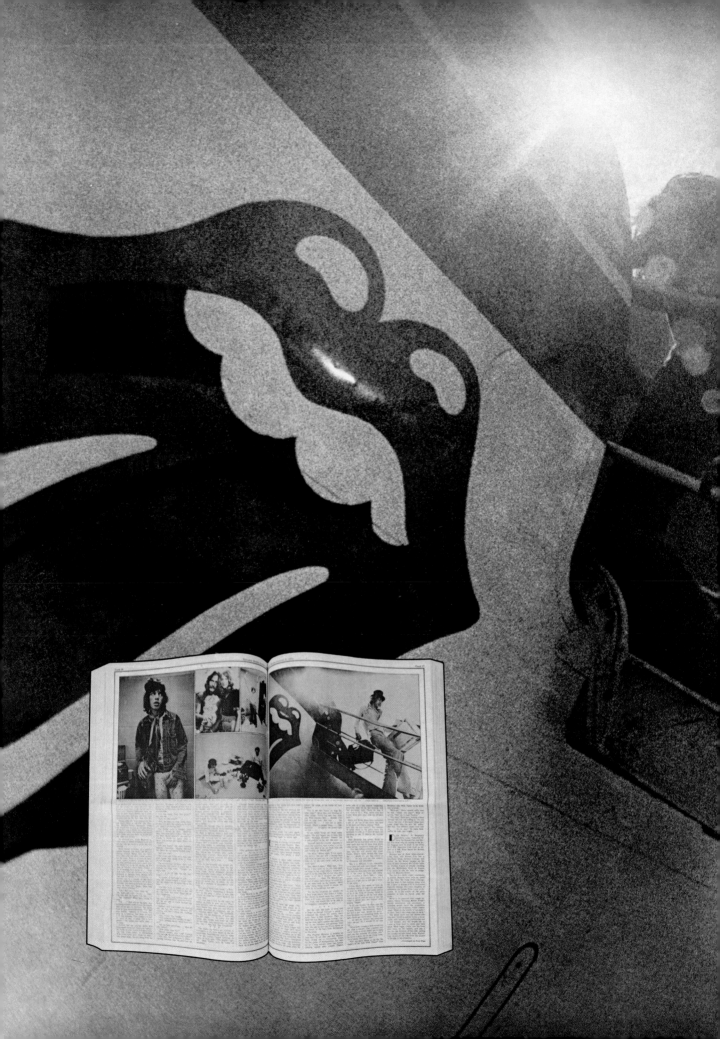

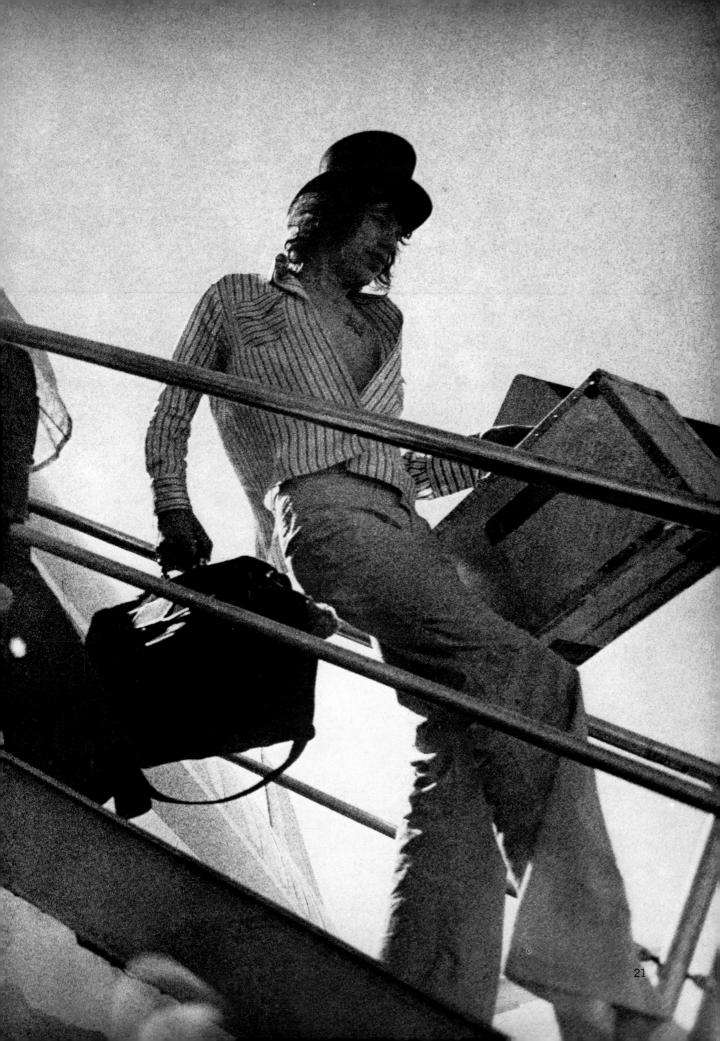

source of desire.

Seven huge arc lights hit a giant Mylar mirror, were reflected, then flooded the Stones with white light as they soared into "Brown Sugar," their opening number. The crowd roared approval. Annie felt it behind her as she had in every city, a combination of excitement and danger as it tried to surge forward. She had watched this performance many times, and by now she knew the working rhythm. She had had to learn it all, their moods, their physical condition, everything. After all, when Keith Richard ran backstage at the Fort Worth concert, hadn't she run with him, her camera ready for a moment of collapse that sprawled across the inside cover of her magazine? She knew something was going to happen, and she positioned herself in front of the stage, penned in by the barricade that separated Jagger, looming above her, from the audience behind her. She looked up and was thankful for Chip Monck's stage lighting; if it was good for an audience, it was good for a photojournalist. The more elements she felt she had under control, the more she could concentrate on Jagger.

She wanted to try a different, more difficult shot than the wide-angles she had taken already with her Nikon. To get in tight on Jagger in these close quarters, she reached for another camera with a 180mm lens and motorized body. She would have to work fast; with a wide-angle there was no problem focusing, but with the 180mm it was almost impossible to keep Jagger in the frame and in focus at the same time. She tried to hold it steady, not wanting camera movement to blur the picture, and as Jagger pranced back and forth, moving, always moving,

Annie's eye followed him in the pentaprism viewfinder. She focused the long lens on his mobile face, trying to capture the sensual tongue she had seen time after time and been unable to catch on film. If she could get it, it would recreate for her viewer the sexual excitement Jagger conveyed to the audience. In a split second his face was framed; the shutter snapped up the image; the frame became empty.

Most photographers put their telephotos on single-lens reflex cameras so they can frame the picture as it comes through the lens. Annie doesn't stop there; wanting to see the exact picture no matter

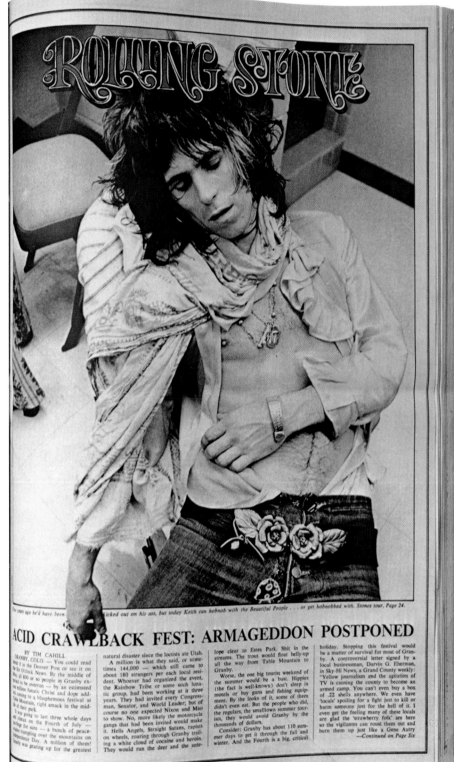

ROLLING STONE

Few years ago he'd have been ... kicked out on his ass, but today Keith can hobnob with the Beautiful People . . . or get hobnobbed with. Stones tour, Page 24.

ACID CRAWLBACK FEST: ARMAGEDDON POSTPONED

BY TIM CAHILL

GRANBY, COLO. — You could read about it in the Denver Post or see it on the six o'clock News. By the middle of May, all 400 or so people in Granby expected to be overrun — by an estimated one million fanatic Christ and dope addicts coming to a blasphemous festival at Table Mountain, right smack in the middle of their park.

It was going to last three whole days at least on the Fourth of July — that's for sure — a bunch of peaceniks trampling over the mountains on Independence Day. A million of them! Granby was gearing up for the greatest

natural disaster since the locusts ate Utah.

A million is what they said, or sometimes 144,000 — which still came to about 180 strangers per each local resident. Whoever had organized the event, the Rainbow Tribe or some such lunatic group, had been working at it three years. They had invited every Congressman, Senator, and World Leader; but of course no one expected Nixon and Mao to show. No, more likely the motorcycle gangs that had been invited would make it. Hells Angels, Straight Satans, rapists on wheels, roaring through Granby trailing a white cloud of cocaine and heroin. They would run the deer and the ante-

lope clear to Estes Park. Shit in the streams. The trout would float belly-up all the way from Table Mountain to Granby.

Worse, the one big tourist weekend of the summer would be a bust. Hippies (the fact is well-known) don't sleep in motels or buy guns and fishing equipment. By the looks of it, some of them didn't even eat. But the people who did, the regulars, the smalltown summer tourists, they would avoid Granby by the thousands of dollars.

Consider: Granby has about 110 summer days to get it through the fall and winter. And the Fourth is a big, critical

holiday. Stopping this festival would be a matter of survival for most of Granby. A controversial letter signed by a local businessman, Darvin G. Eherman, in Sky-Hi News, a Grand County weekly: "Yellow journalism and the agitation of TV is causing the county to become an armed camp. You can't even buy a box of .22 shells anywhere. We even have 'locals' spoiling for a fight just to kill or harm someone just for the hell of it. I even get the feeling many of these locals are glad the 'strawberry folk' are here so the vigilantes can roust them out and burn them up just like a Gene Autry
—*Continued on Page Six*

© 1972 By Straight Arrow Publishers, Inc.

24

what lens she's using, she prefers SLR Nikons all around, just as firmly as Mary Ellen prefers rangefinder Leicas.

Annie traveled well with the Stones. She knew when to take pictures and when to put her camera down—she didn't intrude when they were overtired. There might have been pictures she wanted to take on their private Electra and didn't, but those she got went beyond the endless rumors about the tour, the revelry on the airplane and the Tequila Sunrises their entourage liked to drink. "I was there to take pictures. It was really hard, because there were times when I'd rather relax and think about something else."

The photographs came first. That meant being first off the plane at Fort Worth with a 24mm lens ready to catch Jagger starting down the ramp. (Pages 20-21.) Overexposure didn't bother her; it would produce a grainier picture, but what was important to her was positioning herself so the sun flared dramatically behind Jagger while she still got some detail in the shadows. The wide-angle reinforced the curve of his body and gathered in his surroundings, setting Jagger in context: the mock sensuality of the Stones' logo with the thick lips and lapping tongue leering from the fuselage.

Annie still has not taken "the one picture of him I want, and I don't know what that one is—yet."

People who meet her even casually sometimes find themselves disconcerted by the way she studies them, watching every movement, as if framing them in an invisible lens. Annie explains, "I can't photograph anyone I don't really know." Her camera is a way of establishing relationships and gaining approval, and although it

might seem strange to a first acquaintance to be eyed so hungrily by this friendly cannibal, it is all part of the dilemma and joy of an artistic occupation. To paraphrase Philip Roth, for her there are no good or bad events, there are only potential subjects. Annie the observer, the hunter, watches how other people live. This gives her a mobile security; knowing she is just there for a short while, she can enter another person's life completely.

To photograph someone who is a star, she makes such involvement an asset, convincing herself and her subject that she is a friend, and takes pictures on that basis. "A lot of times I almost have to be in love with a person to be interested in such a concentrated way for such a period of time. I photograph like a madwoman. The best thing to do is just drop my ego. Be nothing. A neutral thing. I just watch, try to go along with what's going on. It's a little harder to do now as I become more known. People are looking at me, expecting me to do something."

As a woman and working for *Rolling Stone,* she has an access to a predominantly male world that most male photographers might envy. She likes photographing men. "The man is relating to me, not to the machine. For a long time I had difficulty shooting women; I felt very awkward and wasn't quite sure how to

relate to them."

Annie might feel that her voyeurism and intense awareness of a subject render her sexless, but she is not averse to allowing the subject an erotic thought. "I let them carry their imagination as far as they think they can. I'm open to it, up to a certain point, just to bring them out."

Annie's frequent shifts of personality revolve around one stable center: her work. And central to her work is Jann Wenner, who founded *Rolling Stone* in 1968 and still runs it as an extension of his own personality. Their relationship is complex. "Jann is definitely top speed. I guess if he's anything to look up to, which I think he is, he's a hard man. I think I'd really have to say it's him I've been trying to please all this time and he's impossible to please."

She insists, though, that she could not be more pleased by the excitement of working for *Rolling Stone,* "because the magazine is so fast on its feet and willing to change to follow what's happening. Where else could I photograph George McGovern one day and Alice Cooper the next?"

Wenner's detachment and determination to make the publication not just an underground but a popular success have changed the atmosphere of the chatty family Annie saw the first day she arrived, to one of those well-ordered magazines that uses market surveys to spur a growing circulation. There are other changes: a few women in high positions—two are listed on the masthead as associate editors, and the copy chief is female. The senior and contributing editors are still all male. Wenner sees Annie as reaping all the benefits of a *Rolling Stone* position, and she does not contradict him. "She's

covered every major rock and roll artist around," he declares, "plus political people. Her understanding of photography has been accelerated by three, four, maybe ten times the pace of anyone her age because we put her into intense situations with some of the very best journalists. I'm a friend of Annie's. She's many different things at many different times."

And she sometimes wonders if she isn't missing something. How long can she continue to make photography the center of her life? "Maybe's it's time to fall in love. I think I'm ready to relax a little bit." She looks up and laughs; she has been photographing without a break for weeks. "No one enjoys people who are constantly at it all the time. It's hard for my friends to be with me when I'm always working. But I love it. And I guess they know that's where I'm coming from Every frame counts. That's what you learn. Every frame counts."

With Daniel Ellsberg, the view alters. Like Jagger, Ellsberg had already received glaring media exposure by the time Annie got to him. She felt his acts had been scrutinized from every angle, sociologically, politically, psychologically. She thought, as she drove down to his beach house in Malibu, it would be interesting to try and use the camera to examine him microscopically, to reveal all the angles of Ellsberg as a scientist would a laboratory specimen.

She set up the shooting outside, using a neutral wall to replace the seamless paper she didn't have. She discovered two sun-shields of white cloth, perfect for reflecting or blocking off the noon light. She placed one on either side of him, and the portraits that emerged through a 35mm lens

25

KODAK SAFETY FILM →26A →27 →27A →28 →28A KODAK TRI X PAN FILM →29

→32 →32A →33 →33A KODAK TRI X PAN FILM →34 →34A →35 →35

showed a variety of Ellsbergs. The back connoted mystery, the unseen face. Gradually she turned him and his face emerged in profile with nose and chin emphasized. There was a hint of the actor as, full face, the formality of the man was relieved by a slight, enigmatic smile. The face began to relax into the informality of a three-quarter view; back to profile. By the end of the contact sheet, the subject had been examined by Annie's multiple views and his face remained still slightly turned towards her camera, aware of exposure.

Documenting the counterculture

Fascination with the exotic, a glimpse into the lives of those people who live very differently from the way we do, has always been a subject for photographers. Diane Arbus, a woman whose work Annie admires, chose to photograph the bizarre and the dispossessed outside the mainstream of the culture. Photojournalism takes us out of our own surroundings, making us tourists in the lives of others before we come home to a familiar reality.

The camera itself creates and destroys illusion. In the hands of a photojournalist such as Annie Leibovitz, it becomes a passport to the exotic, the bizarre, the isolated.

Whether in New York City or Soledad Prison, Annie sees people with needs, people isolated by their success or their failure.

Since she travels a lot, she tries to come prepared for anything—night or day photography in natural or available light, and in some instances she can create a studio-on-the-spot with seamless paper and her strobe unit.

When Annie went to New York to photograph Andy Warhol and the people involved in his studio/production center called The Factory, she took her usual equipment in one camera bag: three Nikons, two of them manually operated and one with motor drive. Annie's reason for using a motor is different from that of most photojournalists, who use the motor wind in sports and quick-action situations where advancing the film manually might mean a loss of photographs. Annie uses her left eye to look through the pentaprism, and since cameras are designed for right-eyed people—with the film advance lever at the right thumb—she must move the camera away from her eye each time she takes a picture. The motor eliminates the problem. She carried an FTN meter to attach to any of the Nikon bodies, and her usual variety of lenses, ranging from her widest at 24mm, to the 35mm she prefers in typical situations, and a 55mm she considers normal for the Nikon single-lens reflex. For telephoto work and close portraits, she took the two she favors, the medium-long 105mm and a 180mm.

Andy Warhol's world became a study in collective consciousness for Annie. Warhol himself seldom spoke more than an occasional "Oh. Hello." He allowed the people around him to do the talking.

One of them was Joe Dallesandro, star of *Trash* and *Flesh,* two of Warhol's movies. Annie borrowed a friend's studio in New York to photograph Dallesandro. She wanted the light to enhance his body, so she unrolled a sweep of seamless paper for a neutral background where window light would hit him at about a 45-degree angle.

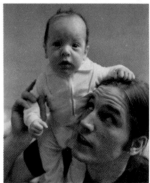

He entered the room, holding his new baby. They chatted a while about the infant, his work, his wife; when Annie felt she had a good connection with him, she suggested, "Why don't we try a few shots over here?"

She used the 24mm lens to get a depth of field that easily kept both father and child in focus even when Dallesandro shifted position. Freed from the chore of focusing, she kept moving around them, trying different angles, but there was still something missing in what she saw, something that hadn't happened yet. She stopped for a moment and made a small joke. Dallesandro responded, then shifted the baby in his arms. The infant woke up and started to squirm. Dallesandro looked into the waiting camera at the same moment the indignant baby's mouth opened in a protesting shriek. Annie caught the action she was sure would happen, the proud display of bodies, father and child, with Dallesandro at his prime, the baby just beginning.

After the shooting, Dallesandro took her

around The Factory so she could make more pictures. One of the girls from *Trash* noticed, walked up to her, and said, "Want me to take my top off?"

Annie looked up, startled. "No. I really don't have any great desire for you to." She tried to sound apologetic.

Warhol chose that moment to walk up and join them. "Yeah," he said, "I'd like you to."

With that, the girl hurried out of her blouse and Annie realized they regarded this as an art form as much as anything else created in The Factory. Warhol picked up his Polaroid and started taking pictures. Then Annie began taking pictures of him taking pictures. Warhol turned his camera on Annie and took a couple of her. She returned the compliment by saying, "I'd like to get a couple of shots of you. Alone. Hold on, why don't we just move this chair over here?" and she grabbed an old wicker chair, hastily placing it between two radiators. She quickly calculated the natural light coming through the windows at Warhol's right. But Warhol had turned away and was busily thumbing through the day's mail. Annie carefully reached over and took the letters from his hand, sat him down in the chair, then stuffed the letters into his pocket. She looked through her lens. It was hokey, she thought, but there was something good about the composition, something she felt might capture a moment of Warhol and pop art, as the radiators, distorted by the 24mm wide-angle, leaned away from the static central figure.

Joe Dallesandro, star of several Warhol movies, had promised his director, Paul Morrissey, that he would quit posing without his shirt, but then came Annie Leibovitz.

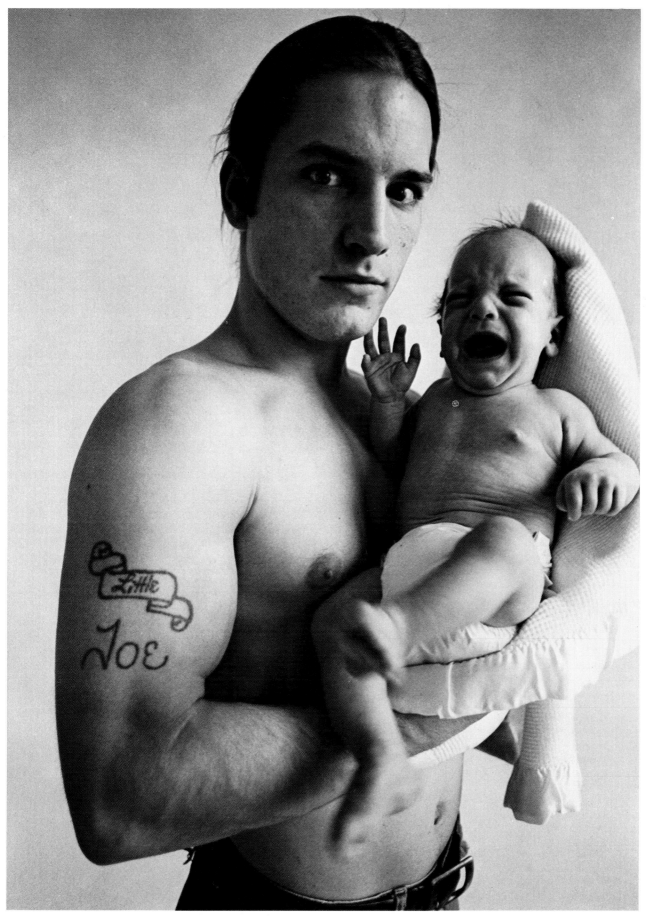

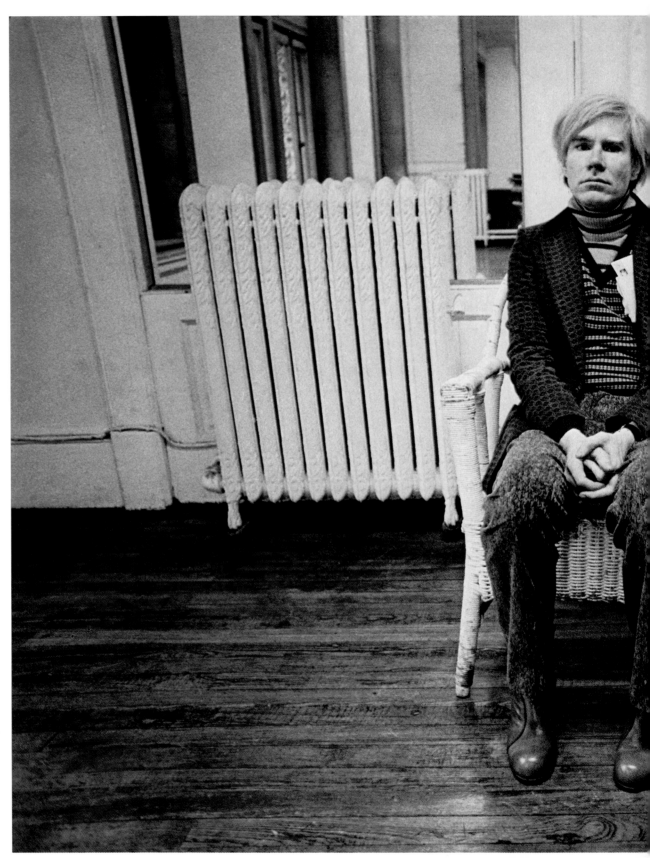

At least
part of the power of
Annie's portraits may be
due to her immersion in
the lives of the people she
photographs. ''I want them
to like me when I'm there.
It's hard with a camera to
be accepted, for me to be
comfortable, or for them to
be. But I really want to
take a fine photograph. So
they open up to me as a
human being because I
demand it of them. The
most fun I ever have is
when someone decides to
work with me on a
photograph.''

During the week in New
York, she photographed
other elements of Warhol's
entourage, including Holly
Woodlawn, one of his
transvestite movie stars.

Early one afternoon, she
went to the apartment
where Holly lived and
knocked on the door. It
opened. Annie started to
say hello, but Holly
immediately hushed her by
motioning at the people
sleeping everywhere in the
room, even on the floor. He
came outside, closing the
door quietly, then
suggested, ''Let's go over
to my friend's apartment.
We can take pictures
there,'' and started down
the hall. Annie followed.
They got into a cab. ''Can
we have lunch first?'' Holly

*Andy Warhol mastered the
pop culture of the 1960's,
''and now everyone wants
him to take their
picture with his Polaroid. It's
really nice,'' says Annie,
''when they want you to''*

31

smiled at Annie. "You're hungry, aren't you? I know I am." Why not, Annie thought. As she paid for the cab, Holly wondered, "Can you manage lunch, too? I'm afraid I don't have any money with me."

After Annie paid for lunch, she took pictures of Holly and his friend on the friend's balcony. Late in the afternoon, Holly remembered an appointment downtown. Just as Holly's cab pulled over to the curb, Annie walked in front of them and said, "One last one?" Her camera caught the goodbye on his lips still

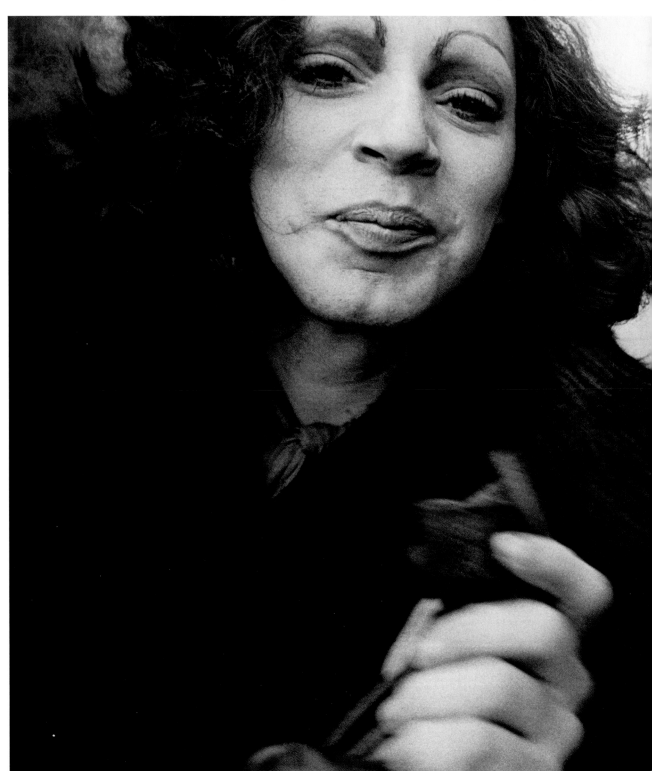

unsaid, as a 28mm lens, opened wide, blurred out the background, making the two figures the major statement without distracting details. Annie's unplanned portrait was an intuitive action, and revealed some of her feelings about that week: ''I guess their sexuality is the thing that attracts me. I wonder about it—and how to capture the feeling they transmit. They're cushioned within their own world, surrounded by their own people, and it allows them to do whatever they want. They seem to be playing with life, even

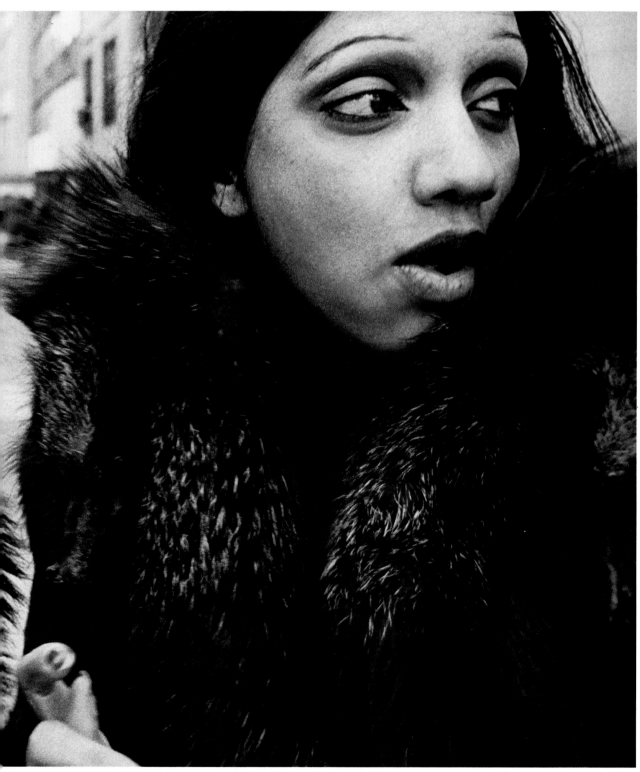

KODAK TRI X PAN FILM

→2A →3 →3A →4 →4A →5

KODAK TRI X PAN FILM KODAK

→8A →9 →9A →10 →10A →1

when they're broke, more than worrying about it. Freaky people are much freer with themselves. I admire that. I can't do it myself.''

Annie enters situations by throwing herself open to them, and as Cartier-Bresson has said, ''the discovery of oneself is concurrent with the discovery of the world.'' Her empathy toward the people she photographs is not pretended: ''They have nothing to fear. I let them see my weaknesses; I'm clumsy, I drop things. And that puts them at ease, I think. Somehow or other, the pictures come out.''

Annie will return over and over again to photograph her subject until she feels some interaction will be apparent in a picture. Such tenacity makes her responsible more to her camera than to anything else.

Friends change. The camera is always there. ''I fight time, the time people

have and the time I can be with them. I have to be really sensitive to what the person is about, what makes them comfortable and lets them know I like them. They have to realize they can be themselves and it doesn't matter. Everything's always all right.''

n a one-to-one situation Annie's ability to create rapport and to direct the flow of energy into a photograph is evident. But the real evidence of her training in photojournalism comes out in situations where there is no studio and she cannot accurately project what will happen to her subject.

In some instances, Annie can be the invisible self she fantasizes, reporting and documenting an occasion rather than directing it.

Her belief that every frame counts means that a contact sheet of 36 pictures might show 20 different situations, instead of the refinements and examinations of one view that mark most other photographers' work. Besides her reasoning that ''*Rolling Stone* only uses one or two pictures,'' she remembers her formal training: ''I learned at the Art Institute that every frame is important.'' A frenetic energy keeps her in motion as she hunts with her curious eye, trying to get the feel of people and their event. The photojournalist learns to anticipate a picture before it happens, by luck or by instinct to know and photograph the right moment.

Rolling Stone heard that an experimental program

would be taking place at Soledad Prison in California; a new superintendent was initiating family day. Annie and staff writer Tim Cahill planned to cover it together. They wanted to be there the minute the gates opened and spend Christmas documenting a human drama.

As they drove down through the rain, Annie thought about the problems the weather was creating. Maybe the people would bunch up together inside, and she wouldn't be able to move about unobtrusively as she wanted to. If she were the only photographer, as Cahill suggested she might be, she'd stand out. If there were other photographers all over, nothing would be spontaneous or natural. And it was raining. She checked to make sure she had her two cameras and the lenses she wanted: a 35mm for wide angle, a 105mm for closeups. Even half-asleep, she hadn't

34

forgotten those when Cahill came by to get her that morning. As they parked the car, Annie asked, "What time is it?" It was almost as dark as when they left. She hadn't brought lights. She had plenty of Tri-X and could push the ASA rating to 1200 if she had to.

"We're right on time. 9:00. You ready?" Cahill asked. As they got out of the car, the wind hit them; it was biting cold. The weather was a continuation of insults. They stood in line with the shivering families to be searched. Annie had a paranoid moment as she thought the guards might not allow her in with her camera. After all, it was a prison. But everyone was permitted to enter. Inside, she began to look around. The visitors were laden with food, bringing something special for Christmas dinner, a touch of home.

She kept moving. She knew her pictures depended on where she would be physically, and the constant movement gave her an overall feeling of what was going on.

Cahill went off to gather his material, and that pleased Annie; "I only go with a writer when time is really short and I know a situation isn't going to happen again. Most of the time I was by myself and I preferred it that way. Occasionally I ran into Tim, but I didn't walk around with him. We each had to bring our own vision to the piece that would run."

She was struck by the activity everywhere and the music thundering out in contrast to the families huddled together, oblivious to anything but themselves. She began to understand the position of the people who had waited in the freezing, driving rain to get in; as they joined, the world narrowed down to joy, and their faces radiated warmth, dispelling the bleak weather, the incessant downpour. Time

became the most important gift, and was freely, lovingly given. Perhaps Annie understood this gift better as a photojournalist than a casual observer might. It was the same gift she worked with and against: time—the time to capture and hold a moment on film until it became real.

"**S**o much could have happened. At the beginning I was confused about why they were given the day.** It seemed a prisoner could escape easily, or someone might have been harmed. But nothing like that happened. It was just all like clockwork and it

For Christmas visiting day at Soledad Prison, Annie caught a different situation in almost every frame.

became a beautiful day with a real family feeling."

One of her fears was realized: she was the only still photographer there. But a Santa with a Polaroid and a few TV cameramen helped to save her from standing out. Besides, people were so wrapped up in one another that they didn't glance up as she framed scene after scene, knowing her pictures would have the immediacy she had hoped for, as the rain diminished and people mingled.

Annie's eye fastened on details. She crowded impression upon impression onto film, exposing just three rolls in all, repeating few frames. Before she was finished, an irony impressed itself into her mind, like images forming on film. Here, in the grim reality of a prison, the traditional Christmas

35

spirit of people drawing close was probably more real than in lush dining rooms overburdened with food in the surrounding suburbs.

The **day was almost over. Husbands and wives were spending the last moments together** and Annie saw two people clinging to each other. (Pages 38-39.) "The husband and wife, whoever they were, were making the most of being with each other. He was leaning up against a mural that some prisoner had painted, maybe even him, and I saw that bird ironically as a symbol of freedom. People paint about things they wish they were. So here were those two, together. And it's prison. I was almost afraid to take the picture; it was all there in that one frame for me. The bird. The prisoner. It was too much. And when I see that picture I almost have to laugh, because I didn't want to take it with everything already in it. It's almost a cheap shot. I think that's one of the few instances I did something consciously in a situation like that."

The last 12 frames (pages 34-35) were the closing moments of the day. The camera pulled away from Soledad, moving from a 105mm closeup of families separating, to a wider 35mm perspective as the distance became apparent. Annie walked out the gate with Cahill. It began raining harder, and she pulled her coat tight around her cameras and herself to ward off the raw

36

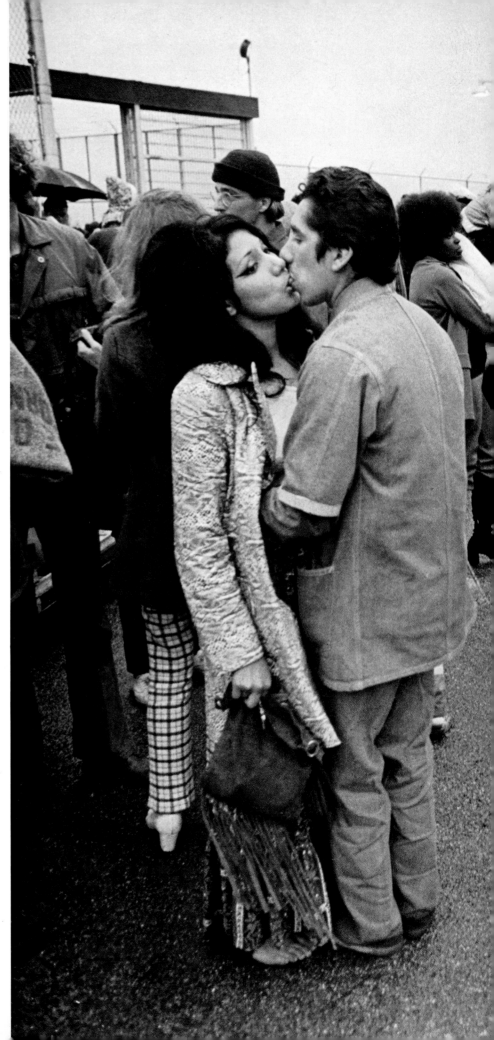

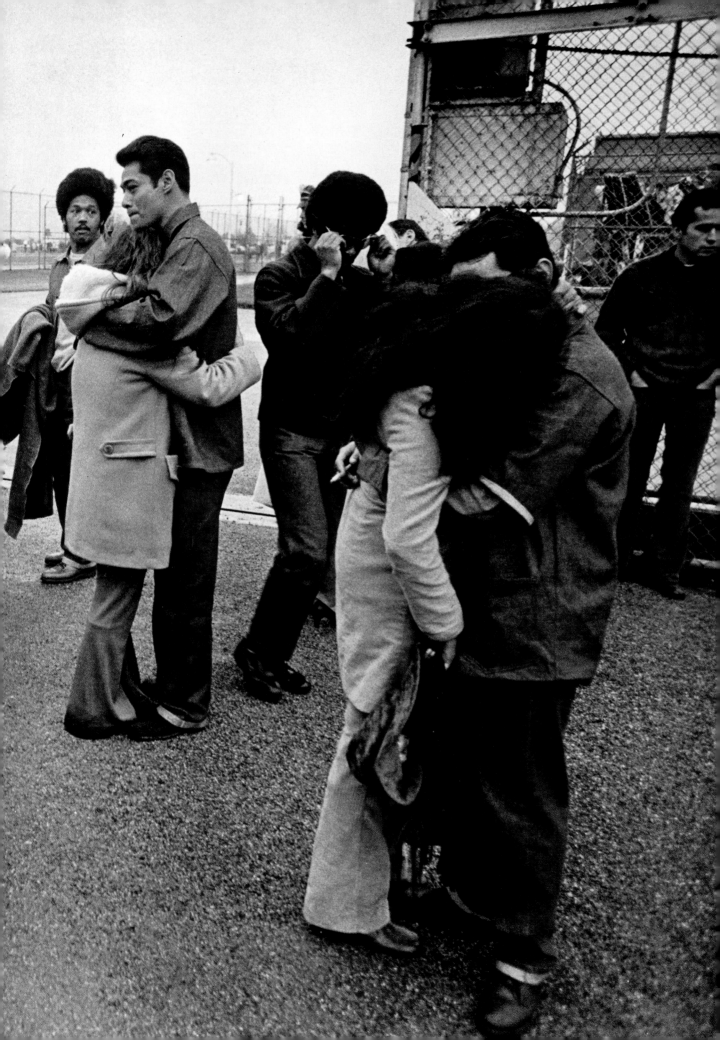

wind that turned the figures ahead into grey, separate shapes.

As they got into the car, Annie thought, "I wonder if I got that intimacy? People are so many dimensions and all I had was one small bit. It was so strange, what was going on there. I understood yet I didn't."

She turned to Tim Cahill and said, "I'm cold." He turned on the heater in the car. A sad smile crossed her face. "People. In cages."

Interpreting personality through portraits

Annie is always looking for one strong, definitive picture for the cover of *Rolling Stone*. To obtain this kind of photograph, she puts the stars she photographs into situations that dramatize her concept of them. She prepares for her subjects, but once in a while, things don't go as planned. What does a photographer do when her plans begin to crumble?

Bette Midler was playing a club in San Francisco, so Annie borrowed a friend's studio nearby and set up her seamless paper. Annie detected a lack of enthusiasm in Midler when they met. She thought maybe Midler would relax once they got going, but as the shooting progressed it became evident that something was wrong.

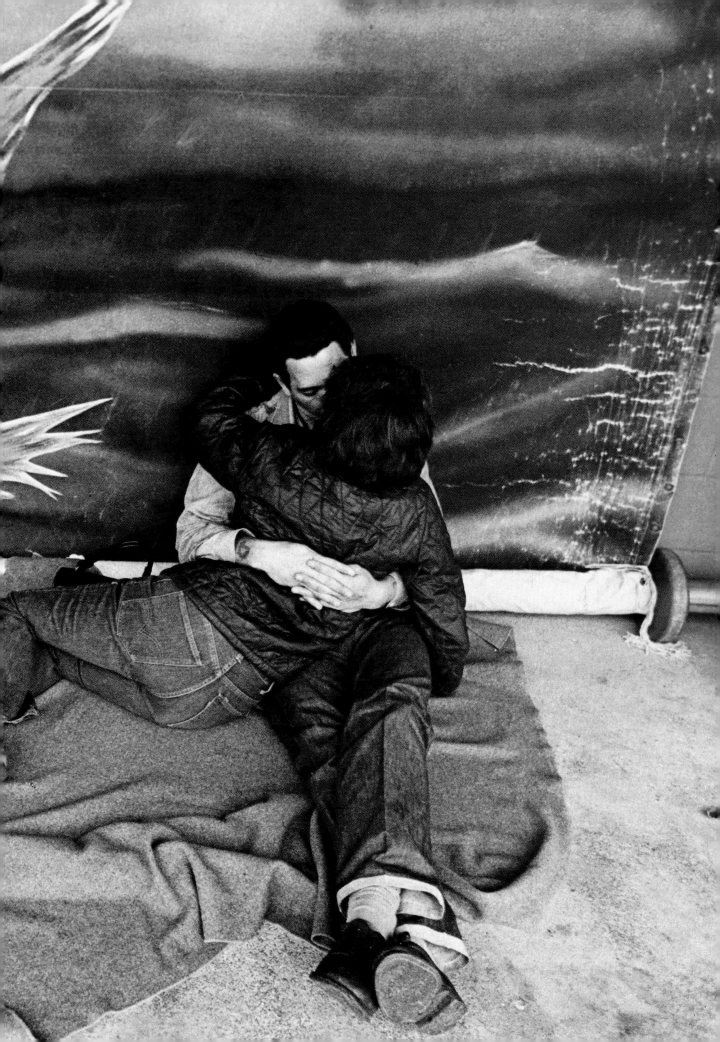

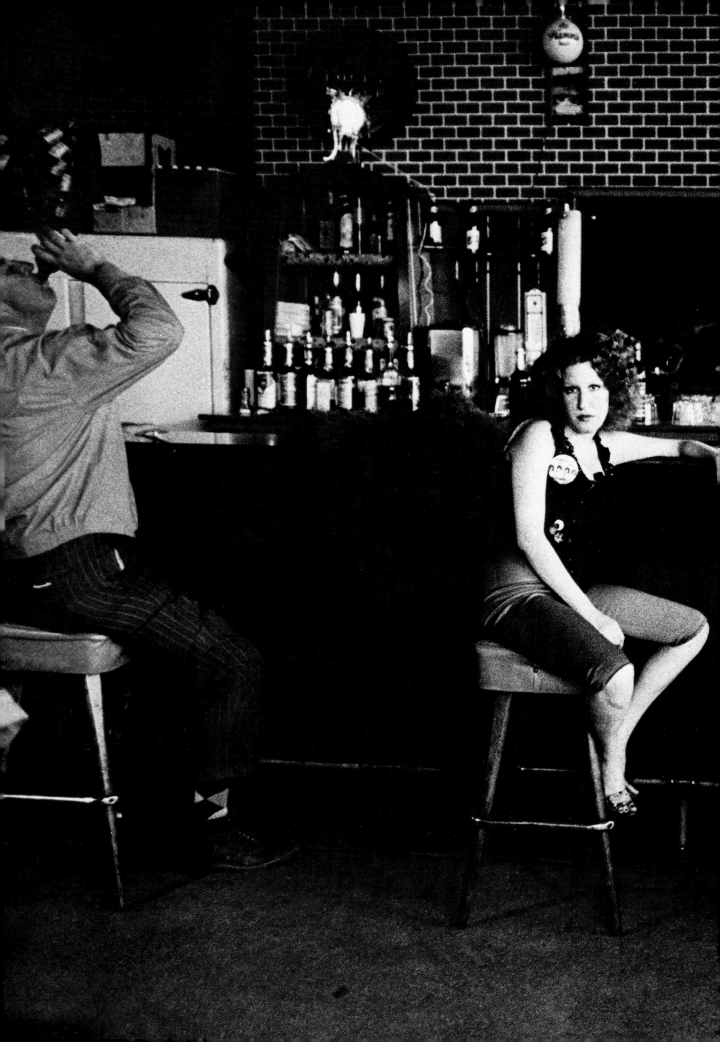

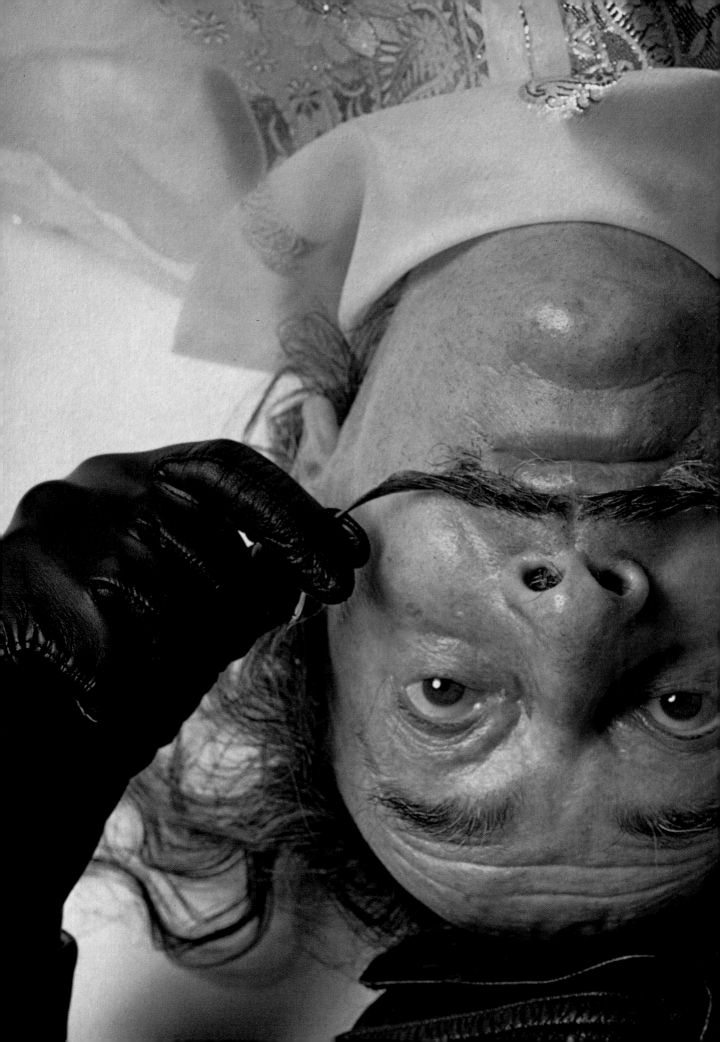

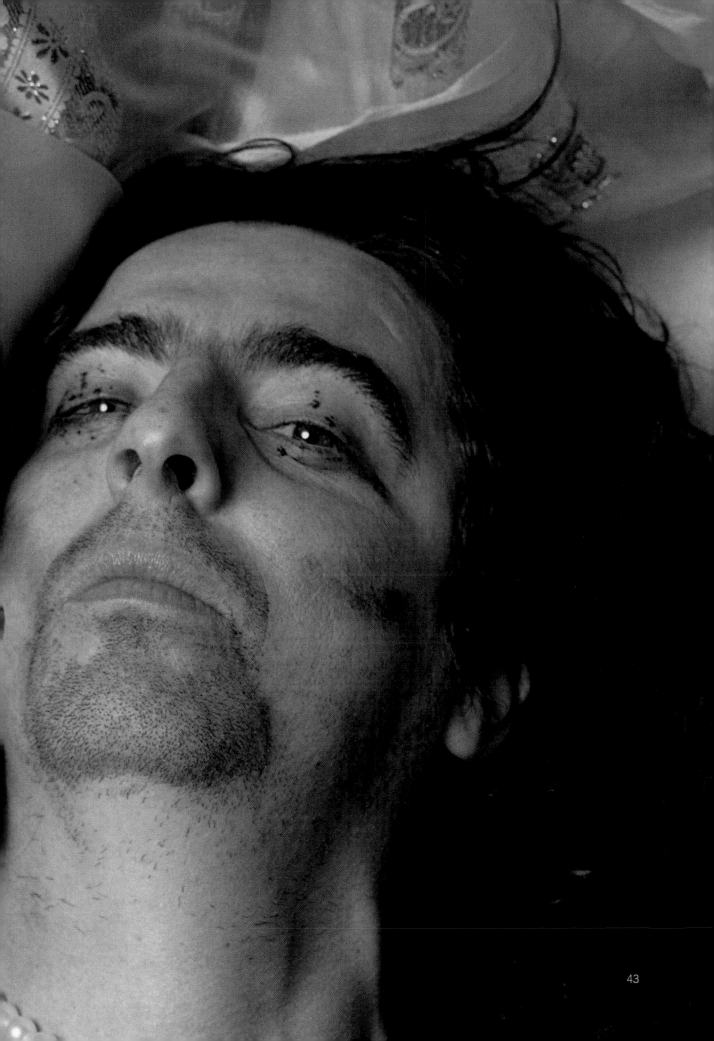

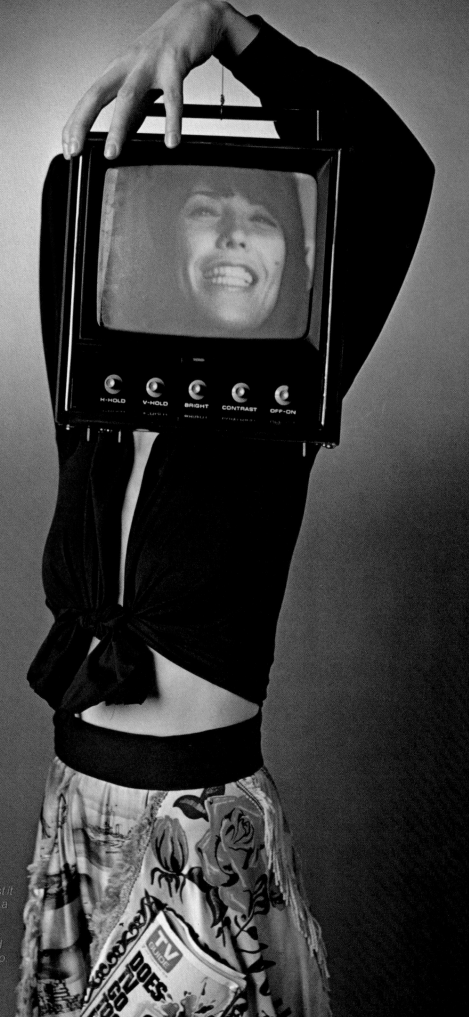

After getting her idea for a
Ms. cover, Annie didn't test it
until she had Lily Tomlin in a
studio. For Art
Garfunkel, she wanted
something surrealistic and
angelic; he hated the photo.

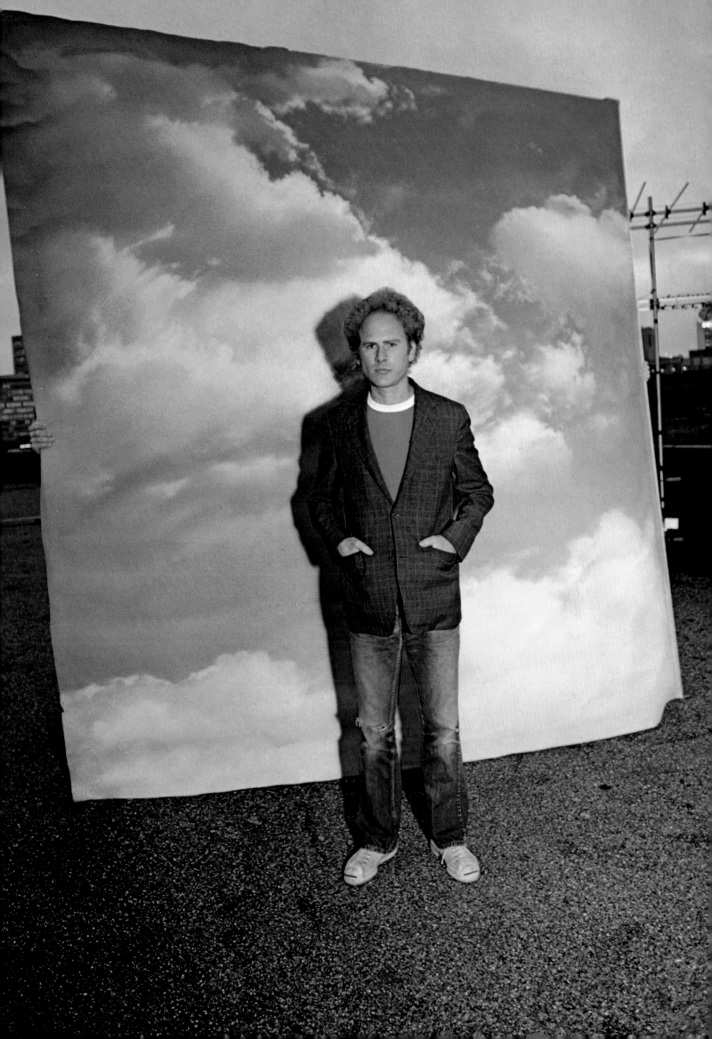

Annie had to do something, and it had to be quick. Suddenly, she remembered a bar around the corner from the studio. "Hey," she said, "let's go outside and see if we can find a place to shoot you. I think I've got a good idea." She hoped if she could get Midler into a more natural setting than the studio, something worth photographing would happen.

As they walked into the bar, Annie spotted two men drinking; there was a lot of room between them. She said to Midler, "Why don't you just go sit down," knowing Midler would probably sit in the middle. The men paid no attention as Midler climbed up on the bar stool, and Annie waited for one to lift a glass to his mouth. When he did, her camera snapped into action; the composition was complete. A 24mm lens expanded the empty space around a slumped Midler, mingling the posed with the natural, which was what Annie had been looking for.

From the loneliness of prison to the isolation of Midler, the dramatic elements that Annie uses make us aware that the intrusion of the photographer into a picture might not be as uninvited as it seems. "Surrealism has always courted accidents, welcomed the uninvited," she remembers from art school. People who *are* their art become more and more isolated, Annie feels, and the surreal glimpse of a photographer who includes herself in their recorded moments is evident in another picture, with singer Ann Peebles (pages 6-7) in Los Angeles.

The initial contact in the afternoon was awkward. Peebles was shy, there were other people there. Annie knew the pictures she got weren't what she wanted. Instead of leaving town as she was supposed to, she took her strobe box

back to Peebles' dressing room before stage time that night. This time, Peebles was alone. Annie had her change into a dramatic costume and looked around the room. She noticed disarray, a dress with its plastic cover half-hanging, a black telephone. Could she use the static objects to identify a woman locked into herself? She didn't plan to include the brilliant flash of the strobe, but a 24mm lens in the small room with a mirror dominating took it in. The images repeated: woman, stark room, a momentary flash of involvement.

Since Annie must often make portraits away from the convenience of a studio, she tries to think of devices to create her studio on location. She knew she was going to photograph rock star Alice Cooper and surrealist Salvador Dali. Sitting in a New York restaurant, 3,000 miles away from her studio in San Francisco, she was glad she had taken her bulky strobe assemblage as she found herself doodling on a napkin: two heads, one upside down. She sketched a rectangle around the two circles. A playing card. She was sure Cooper would do what she intended. Dali? That might take a bit more arranging.

Four hours before Dali's show, "Hologram," was scheduled to open, she went to the gallery where it was set up and found an empty room upstairs. She sent out for seamless paper, set up her strobe, then glanced at her watch. Dali was scheduled to arrive any moment. Looking around the room once more, she made sure everything was ready: there was no time to waste fussing with equipment. She walked downstairs and waited by the entrance; the moment Dali came in, before the crowd got to him, she grabbed him. One arm on Dali and the other

on Cooper, she took them upstairs and said, "O.K., get down on the floor."

Dali swirled around and noted that Cooper was dressed all in black leather. He looked at his own leopard-skin jacket, then snapped his fingers. An assistant hurried over. Out of a paper bag came a brocade caftan. Dali changed immediately; he wasn't about to be upstaged.

Annie, observing from behind her 55mm Micro-Nikkor, thought, "Christ, that man really has it together. He's prepared for anything."

Colorful people carry the picture in a setting that is unusual but simple. (Pages 42-43.)

Perhaps her pictures of Lily Tomlin and Art Garfunkel (pages 44-45) are the two most surreal, humorous and thoroughly planned Annie has made. She thought the commedienne should appear where most of her fans would expect to see her, in a television set. Not only that, but she wanted "a kind of surrealistic portrait, the black and white mixed with color." Annie rented a studio in Los Angeles, baby spotlights, and three television monitors of different sizes. After a test, the smallest monitor seemed right, so she had it hung on a wire. She then stood Tomlin behind it with her arms seeming to embrace it, and told her to mug to a video camera at Tomlin's right. Annie shot the image seen on the monitor, using a 28mm lens that allowed her to get

in close and fill the frame easily while keeping Tomlin's body and hands in sharp focus.

The sweet-voiced Art Garfunkel struck her as somehow angelic, and she began toying with a thought: Garfunkel singing, his mouth open like an angel's. She found a backdrop of painted clouds and hung it in her studio-apartment. But as she was driving down to *Rolling Stone* to pick up Garfunkel, another thought occurred. Why not use the drop as the illusion it was? She looked up at the sky; the late afternoon cloud formations would soon dissolve into night. Wheeling the silver Porsche in a screeching U-turn, she sped back to her studio, left the motor running as she rushed up three flights of stairs, ripped the clouds down, then jumped back in and hurtled towards the office. Her strobe box was already in the car, and she calculated the minutes that would be spent putting it up. Would there be light enough to do what she wanted to do? She ran into the office, grabbed Garfunkel and two helpers. Everyone converged on the roof. The light was almost gone, and a wind had come up. The two men holding the backdrop found themselves holding a sail. Annie wouldn't have her shot spoiled by anything, especially not two men almost being blown off a roof. She yelled, "I know you can hold it. Hold it!"

Using a 28mm lens to achieve the Magritte-like photograph she desired, her determination paid off as the last moments of light faded away. She had her picture: one illusion stacked on another illusion. A week later, when Garfunkel saw the prints, he thought he looked terrible. Annie's concept of

Annie saw sexual symbolism in Eric Anderson's zipper.

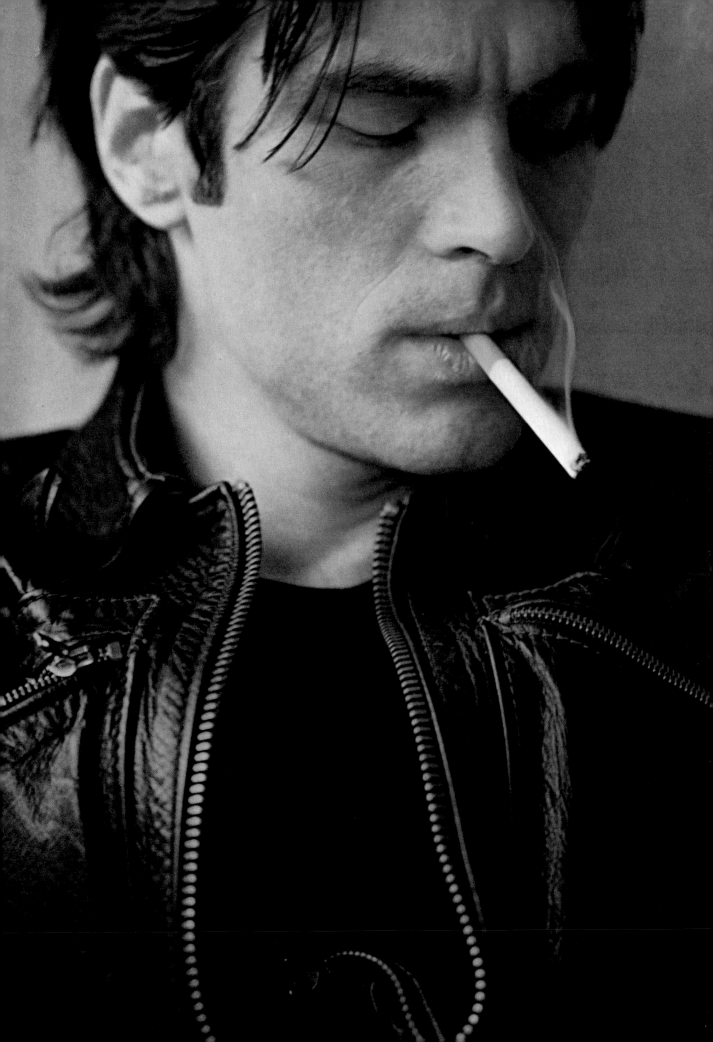

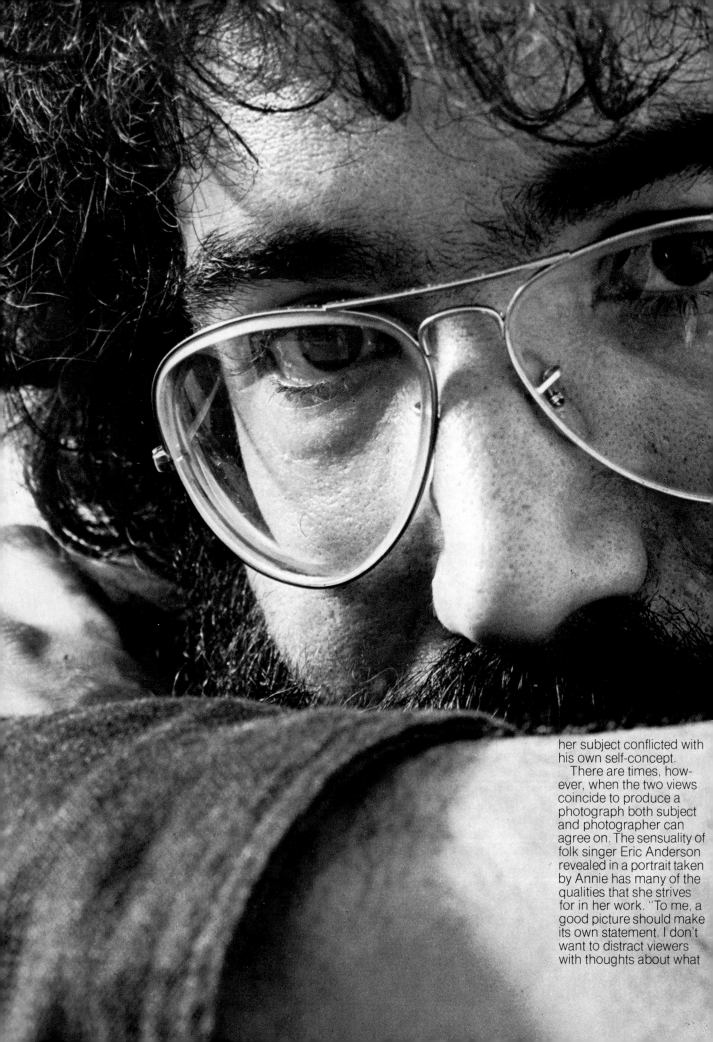

her subject conflicted with his own self-concept.

There are times, however, when the two views coincide to produce a photograph both subject and photographer can agree on. The sensuality of folk singer Eric Anderson revealed in a portrait taken by Annie has many of the qualities that she strives for in her work. "To me, a good picture should make its own statement. I don't want to distract viewers with thoughts about what

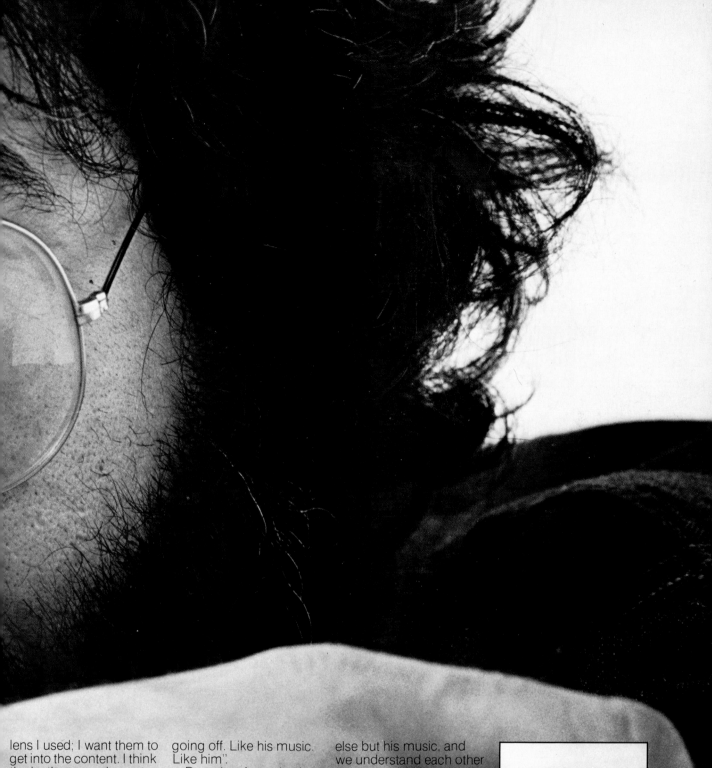

lens I used; I want them to get into the content. I think the leather complements Eric, the zipper coming down is very sensual. It doesn't matter that I was using a 105mm lens to get really close up, or that it was natural light coming through the windows. What matters to me is that I felt like a tripod. I was just there, recording, and I didn't have to do anything or say anything. It was like two molecules meeting in space for a little bit, then going off. Like his music. Like him".

Portraits of people close to Annie are, not surprisingly, her most intimate. Rock star Jerry Garcia of The Grateful Dead (above) is someone she respects because he is into his world as much as she is into hers. Of Garcia, she says, "Among all the people I've photographed, he's the one person whom I've allowed myself to be a friend to. He needs nothing else but his music, and we understand each other right away because I live for my photography."

Of Annie, Garcia says simply, "When she photographs people she doesn't threaten them. You're always aware of the *person* behind the camera".

Annie can involve even a stranger with her personality, instead of her camera, to set up a suggestive pose. The day after she met him,

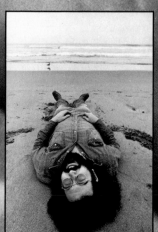

49

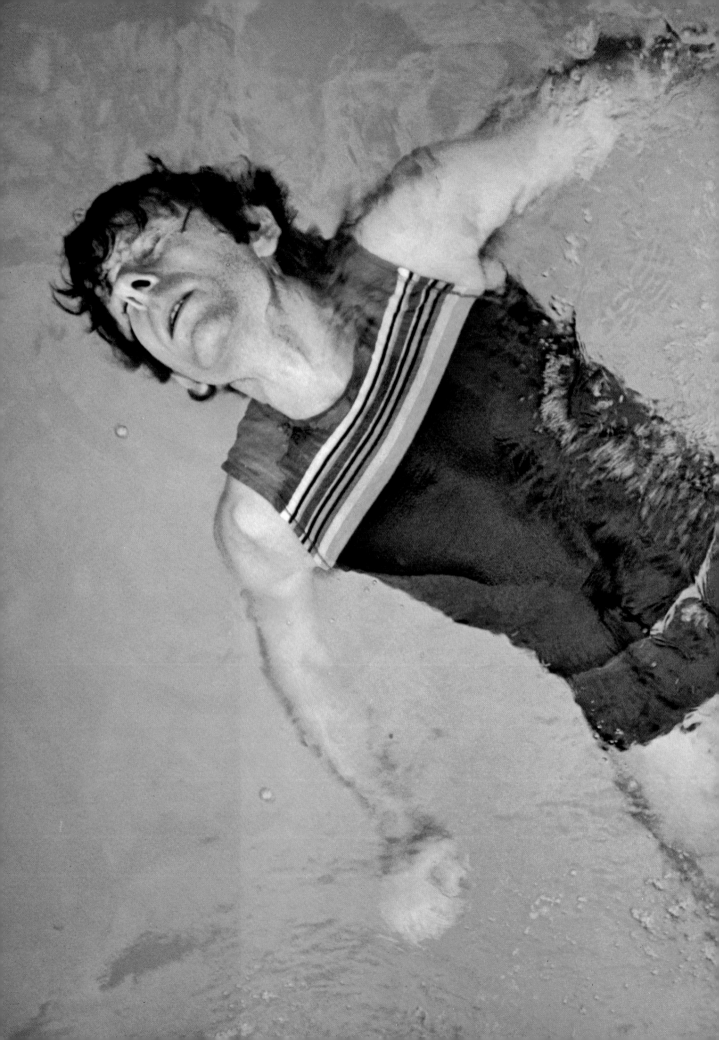

Roman Polanski—a director whose films deal in mystery and horror but whose presence conveys vitality and sensuality—agreed to mark his return to Los Angeles by floating, eyes shut, in a pool not far from the place where his wife had been murdered five years before.

The natural **sensuality that Annie sees in some of her subjects** has also been the basis for an intimacy she created for a star who was noted mainly for his boyish cuteness. An ad in *Rolling Stone* attests to continued reader interest in two pictures that ran, front and centerfold, in 1972:

DAVID CASSIDY ISSUES, wanted. Fan wants to buy Rolling Stone *with David Cassidy reclining on front cover. Will pay ten bucks for one in good condition*

It is one thing to take a photograph of a male symbol like Burt Reynolds, but Annie's assignment wasn't the typical he-man star. Cassidy had risen to his own kind of eminence as the idol of the 13-year-old bubble-gum set. How could she convince him to pose nude for *Rolling Stone?* She did some research and found out that Cassidy had begun to take his singing seriously. Also, his young audience was getting a bit shaky. With that in mind, she drove down to her home away from home, Los Angeles, and talked to him about the audience *Rolling Stone* would provide, a peer group audience, something he deserved.

S

he convinced not only Cassidy but everyone around him, and on the day of the shooting she came prepared with lights and an assortment of lenses, from her 35mm to a 105mm telephoto. Her first idea for a setting was water, but his pool wasn't heated, and it was easier to start in the house. She remembered a picture of Vanessa Redgrave taken by Victor Skrebneski and asked Cassidy, ''Can you put your arms, sort of, around yourself? Yeah. Like that,'' as she framed him with her 35mm. That was the picture she needed, so she went back to her idea of water for the other. She tried to use the bathtub, but its only virtue was that it held water. The light was too harsh and the situation had a stark quality she didn't want. If she couldn't have the pool, she'd have to settle for the grass around it, so she led Cassidy outside. ''Lie down here,'' she instructed. He did, and continued to cooperate easily, picking up Annie's assurance as he let her photograph him both clothed and unclothed.

The pictures ran as *Rolling Stone's* first nude—as far as it went—cover and centerfold. That added to the real pleasure Annie takes from her work: ''I like taking pictures of people who are famous. I'm recording images, not a reality. I want the viewer to believe in the reality of my photographs. Where it happens, when it happens, is where I am. The camera tells me who I am. It's my discipline.''

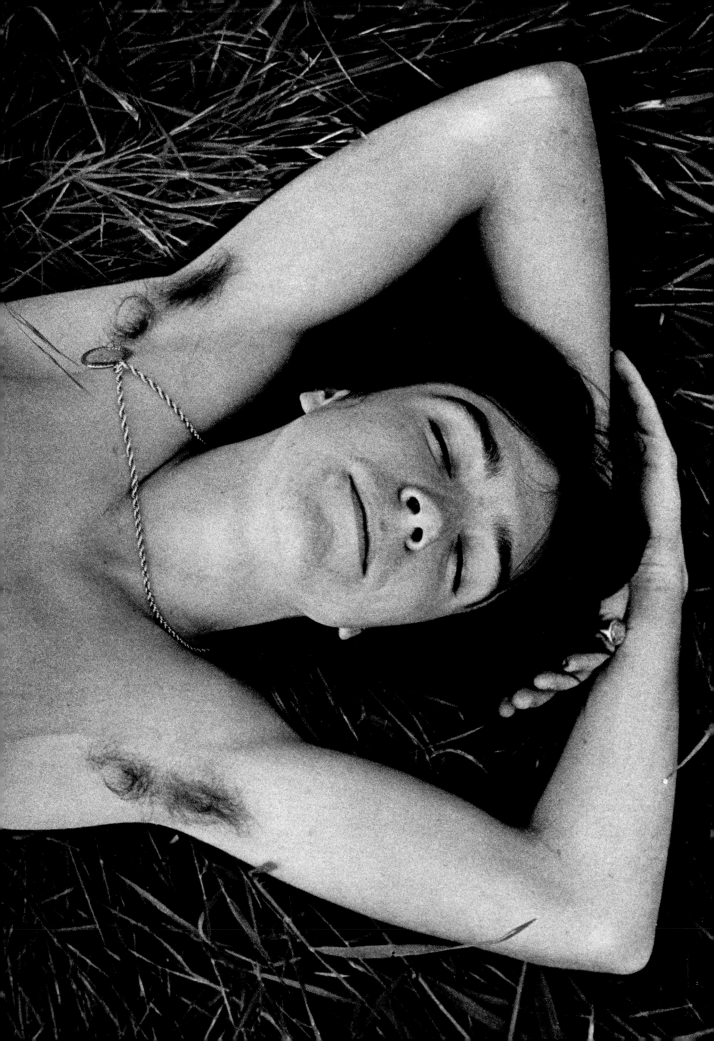

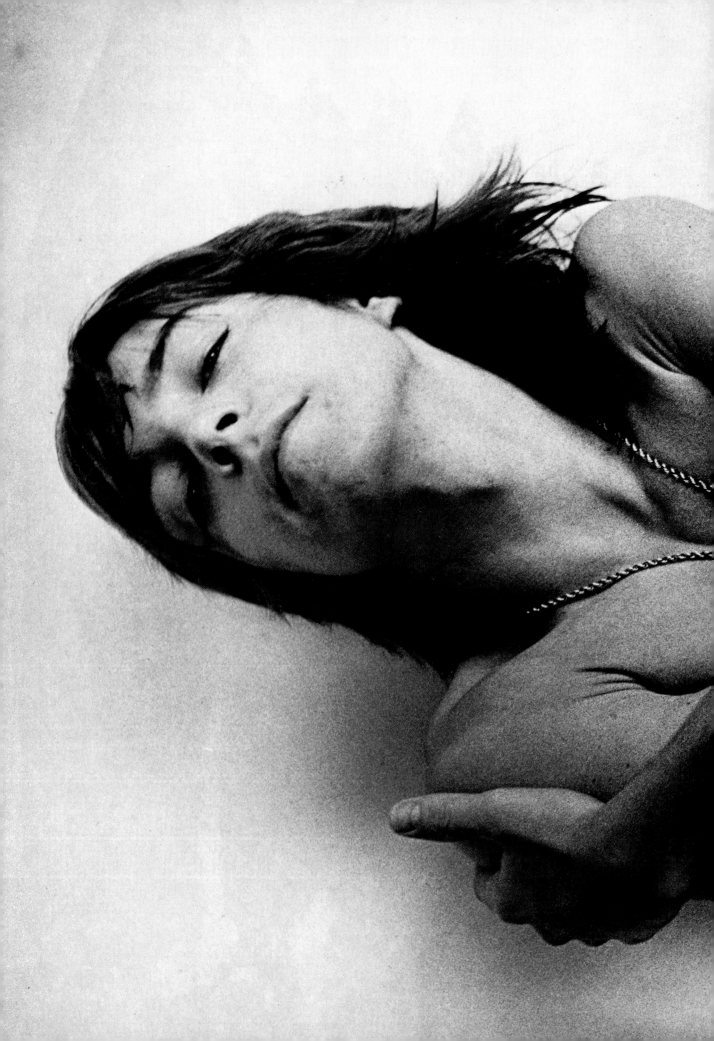

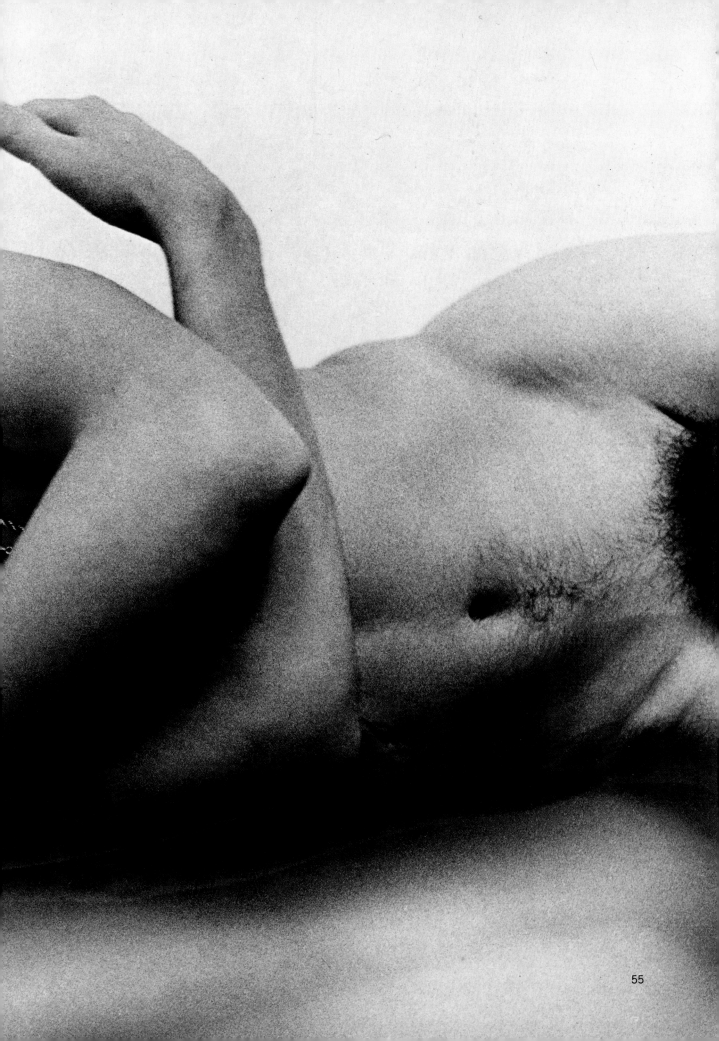

Mary Ellen Mark
Using the camera to explore spaces between people

When a photograph fixes an event in space and time, it imposes distance. A moment of pain or joy isolated in a single frame makes its own statement, but a photojournalist can also explore a theme while she records an event. By grouping pictures, she can examine life or a group of lives in depth; each photograph heightens the reality of a situation and uncovers another facet. The pictures often gather strength by reflecting and reinforcing each other.

Mary Ellen Mark explores the spaces around people. Her single pictures are powerful studies of individuals and their surroundings; her essays and portfolios provide perceptive glimpses into their relationships.

Perhaps her childhood, an isolated time when she felt very much alone, made her aware of the separateness of people. Even today she finds photography lonely work; there is always the camera between her and the subject, and her photographs explore the

space as much as they explore the subject.

"When I see something that registers, and I feel that it's worth photographing or that it's going to make a statement, all of the little things in my past and my present are making me believe. It's emotional. And I respond."

If Annie uses her camera to reinforce the public image of her subjects, Mary Ellen uses hers as a tool of exploration to peel away the layers of convention that are usually all we see of people. Even if her subject is a movie star or a pop singer, she captures the unexpected. She sees beneath a polished surface to the shadow side, or allows tenderness to preserve its integrity.

Photojournalists like Mary Ellen and Annie prefer to work anonymously. But if nothing is happening to convey her particular insight, Mary Ellen is as likely as Annie to direct the subject and make something happen.

Working on an assignment called "Craziness in California" for *Paris-Match,* she was introduced to two of the

Cockettes, transvestites who performed outrageous song and dance routines after the midnight movie in a San Francisco theater each weekend. They had already achieved notoriety; constantly photographed, they were the current fad. Rex Reed and other columnists found transvestites the camp thing to write about, and for a while the Cockettes were the group to see in San Francisco.

Any photographer could produce a bizarre picture from such bizarre ingredients. Not wanting to take advantage of their crazy makeup and melange of lace and feathers, Mary Ellen decided to penetrate the facade of theatricality and show a human interaction. To do this, she relied on two major elements: lighting and a believable construction of intimacy.(Pages 2-3.)

The first was no problem, thanks to typical San Francisco weather. The city's high fog produced a soft, diffused light, exactly what she wanted. It also helped solve the second problem. She could have reproduced the light she wanted in a studio by bouncing a strobe off an

umbrella, but she wanted to remove any trace of staginess that might work against her, and a studio situation was too neutral. She had looked around and spotted a potential background: the outside of a building. The faded wall was just the touch of context she needed. She asked the men to come outside, and as they approached her, she framed them in a 35mm lens. When they were close enough to connote intimacy yet still allow her to include a bit of the background, she stopped them and said one word: "Dance." A casual direction was all they needed; they reached out and joined hands.

It was the reaching out, the tentative gesture, that intrigued her, as it had years before when Ralph Gibson photographed her in New York. Friends since the beginnings of their careers, when they shared a darkroom in the Chelsea Hotel in New York, she and Gibson were never competitors;his work has taken a decidedly different direction from hers. While she built up a strong photojournalistic reputation, he has become

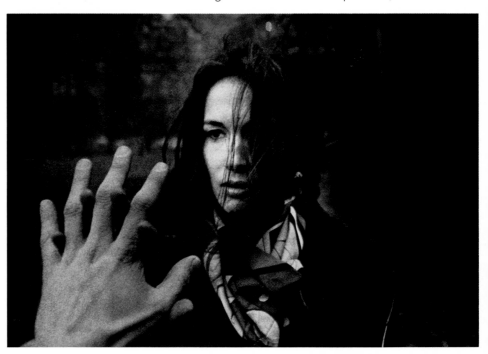

known in galleries, museums and books. He has influenced both Annie and Mary Ellen: both consider a 35mm lens the "natural" lens, closest to the way they see, and this tenet is something Gibson taught to Annie at the Art Institute, to Mary Ellen in private conversations.

Part of his relationship with Mary Ellen was captured in "The Enchanted Hand," a photograph taken in 1967 that explores some of the action between photographer and subject. Gibson's hand became an extension of the camera as Mary Ellen's fingertips made contact; it is up to the viewer to decide if the hands are intertwined or merely touching. Gibson feels the interchange expressed in this picture is a collaborative venture: "It's like freedom or love; you can't hold something too tightly or it dies. You must leave your hand open. Mary Ellen and I have tried to do sequels to this photograph, but this is still the strongest one."

Over the years, they have continued to make pictures of each other, and when *Viva* magazine asked Mary Ellen to do a male nude photograph, it was natural for her to phone Gibson and ask, "Ralph, how would you like to pose for me? Nude." His warm laugh signified interest and they began to talk about a way to do it. For two days they tried to think of a pose that would be both whimsical and artistically pleasing.

Again, as she had done with the Cockettes, Mary Ellen first figured out her background. Once a photojournalist has determined that, making sure the environment is not cluttered with distracting details like a pipe appearing to grow out of someone's head or a window sill bisecting a body, she is free to concentrate on the subject.

The corner of Gibson's studio loft was perfect; she could use the natural light coming in from the corner windows to throw part of his body in shadow while highlighting other features. For her nude study, mystery and exposure were equally important, and lighting had to emphasize that. They tried a variety of poses, but none had the qualities they were looking for until Gibson remembered an old prop. A mask. Mary Ellen placed it at his feet, but it seemed static; the mask and the man were unrelated. While she aimed her 35mm lens, he gradually moved the mask up from the floor to various positions on his body. When it reached his genitals, Gibson struck a profiled pose and Mary Ellen snapped the picture they wanted, a humorous study. (Pages 58-59.)

This was one of the first times Mary Ellen considered the differences in difficulty between photographing men without clothes and women without them. "For some reason, I don't know why, it's all so new, showing the man totally. Ralph and I talked about frontal nudity and whether to show his penis or not. We decided it wasn't necessary. It's the sort of thing that could be so exploitative, especially when you're photographing a friend. A lot of times the types of men who pose for those shots are simply exhibitionistic. There have been much more artistic studies of unclothed females than there have been of males." Mary Ellen wanted more than a photograph that registered a set scene; it also had to register intent, some kind of live intelligence.

Although Mary Ellen and Annie are aware of the emotional effect of color, and would like to use the slower films that provide richness of color tone, Mary Ellen most often finds herself using Ektachrome X.

A stop faster than finer-grained color films, it lets her operate in situations where light might be a problem. She has always worked with color. Unlike Annie, she finds it basically easier than black and white. "I don't have as much latitude as with black and white, so I can't let myself make exposure mistakes. But exposure mistakes don't happen so much after working this long; you get to know your film and the light and you think more of the photograph than the colors in it. After all, they're right there."

She used color to accent the composition of her portraits of Steven Arnold and a young woman who calls herself Valli (pages 60-61), but still focused attention on her subjects—the primary concern of a photojournalist who counts on her pictures to convey not only beauty but information.

Working intensely in journalistic situations, Mary Ellen prefers a Leica although she has Nikons and uses them. Since the day in graduate school when she first held a Leica, the rangefinder camera— easy to focus and fast to operate—has become almost an extension of her hand and eye. She chooses it for weak-light situations because she can hold it steadily for exposures up to 1/15 second. But the real advantage, she feels, is its silence; any single-lens reflex makes an audible sound as its mirror snaps up at the moment of exposure. By comparison, the rangefinder camera is virtually inaudible. Her normal lens is the 35mm because "I think it's the closest to the way I normally see." Since she strives for a picture that looks natural to her, the 50mm lens most people consider normal is spacially more difficult for her to compose with; the lens gets in the way of the picture. The 35mm lens includes more of the context of the subject.

Steven Arnold, a filmmaker and designer who also performs as a mime, had introduced her to the Cockettes in San Francisco; he had been

inside in his studio while she photographed them. When she returned 10 minutes later to thank him, she asked Arnold to come out and pose, mentioning the beautifully diffused light the high fog had created. They tried a number of poses, but when Arnold cocked his head, looking like a sad clown, then folded his hands in front of him, the composition was complete. She snapped the picture. (Page 61.) She let the portrait of the Cockettes and of Arnold each make its own statement, using the space around the figures differently. For Arnold, she went to a 28mm lens; by placing distance between herself and Arnold, she manipulated and isolated the mime and visualized pathos; with the 35mm she had used for the Cockettes, she closed distance and brought them and the viewer into rapport.

A rapport with people has been evident in Mary Ellen's work from the very beginning. She does not feel she has to know people to photograph them. Using her camera as a tool of exploration, she learns about them and their lives. She will even approach strangers, as the photograph of Valli testifies. She had just started to photograph when she went to Europe in 1965. It was two years before pictures of flower children with gypsy clothes, beads and rings would become commonplace. Mary Ellen was sitting in a small restaurant in Positano, Southern Italy, when she saw a woman wearing an incredible assortment of necklaces and rings, dressed in a fashion that defied current fashion. It

For Mary Ellen Mark, shooting a nude of a friend like Ralph Gibson presents a few problems: ''It's all so personal''

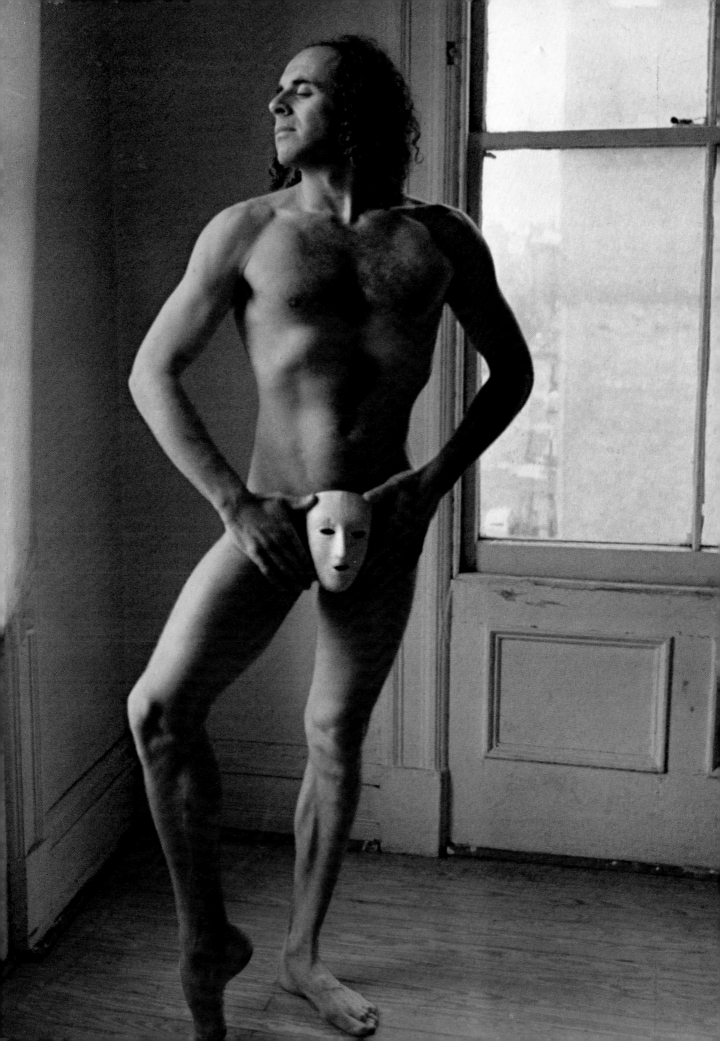

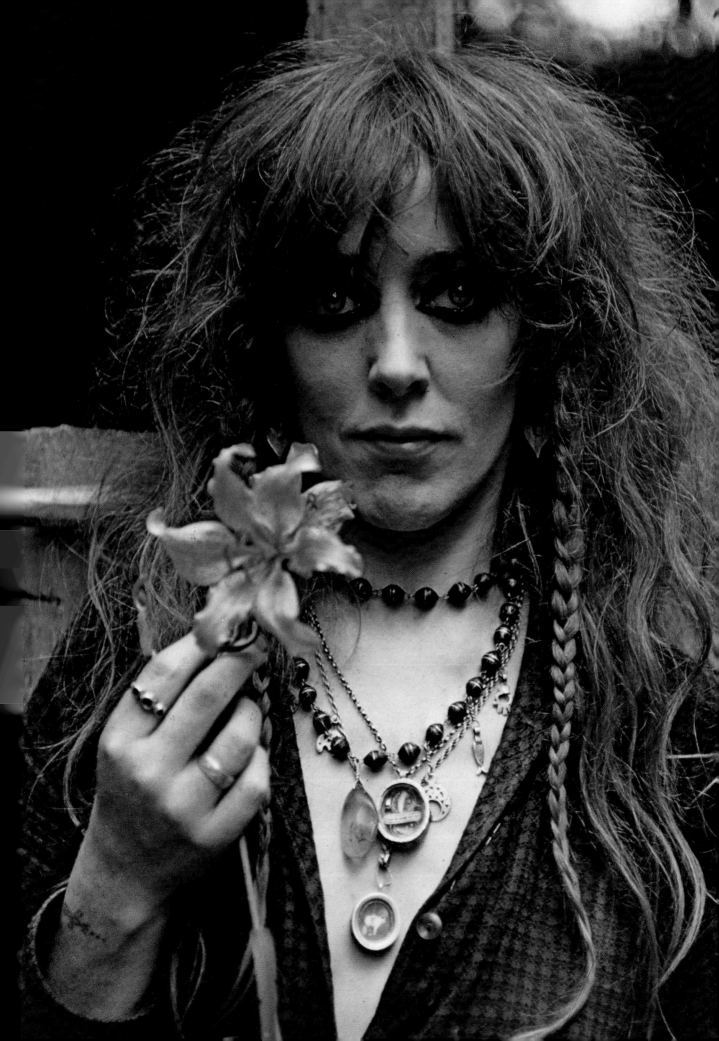

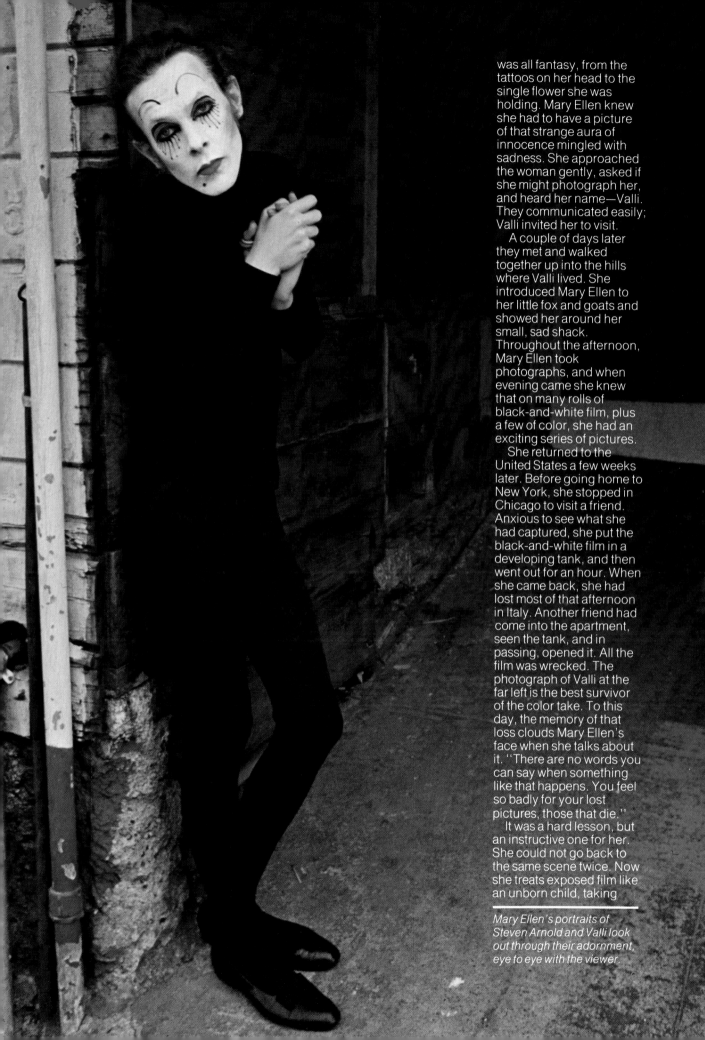

was all fantasy, from the tattoos on her head to the single flower she was holding. Mary Ellen knew she had to have a picture of that strange aura of innocence mingled with sadness. She approached the woman gently, asked if she might photograph her, and heard her name—Valli. They communicated easily; Valli invited her to visit.

A couple of days later they met and walked together up into the hills where Valli lived. She introduced Mary Ellen to her little fox and goats and showed her around her small, sad shack. Throughout the afternoon, Mary Ellen took photographs, and when evening came she knew that on many rolls of black-and-white film, plus a few of color, she had an exciting series of pictures.

She returned to the United States a few weeks later. Before going home to New York, she stopped in Chicago to visit a friend. Anxious to see what she had captured, she put the black-and-white film in a developing tank, and then went out for an hour. When she came back, she had lost most of that afternoon in Italy. Another friend had come into the apartment, seen the tank, and in passing, opened it. All the film was wrecked. The photograph of Valli at the far left is the best survivor of the color take. To this day, the memory of that loss clouds Mary Ellen's face when she talks about it. "There are no words you can say when something like that happens. You feel so badly for your lost pictures, those that die."

It was a hard lesson, but an instructive one for her. She could not go back to the same scene twice. Now she treats exposed film like an unborn child, taking

Mary Ellen's portraits of Steven Arnold and Valli look out through their adornment, eye to eye with the viewer.

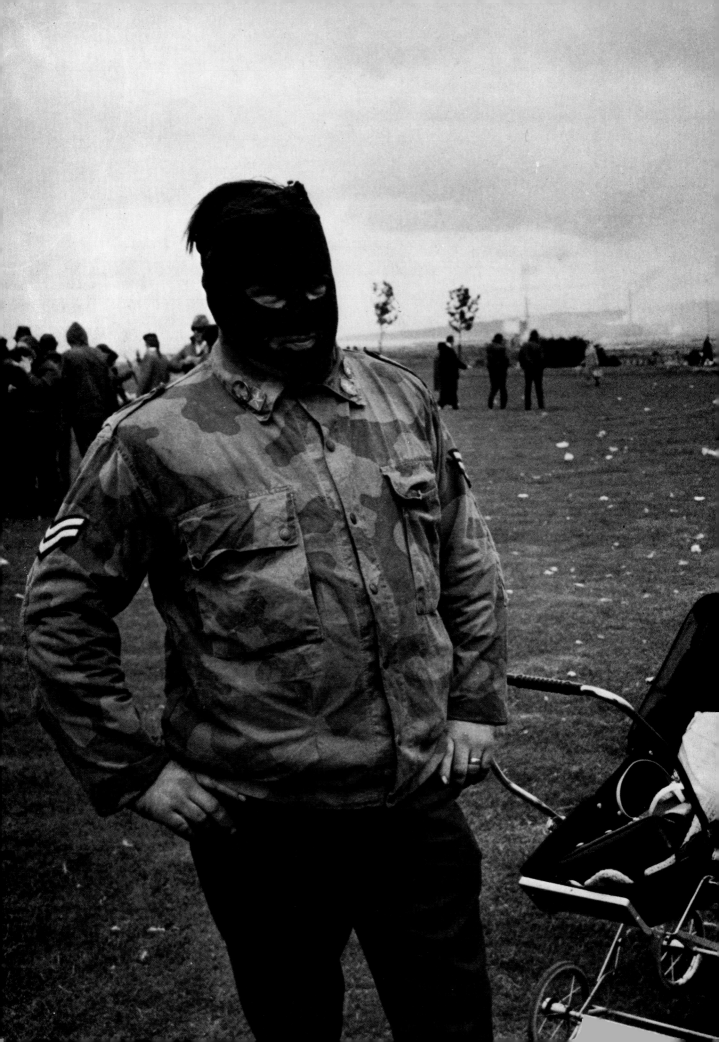

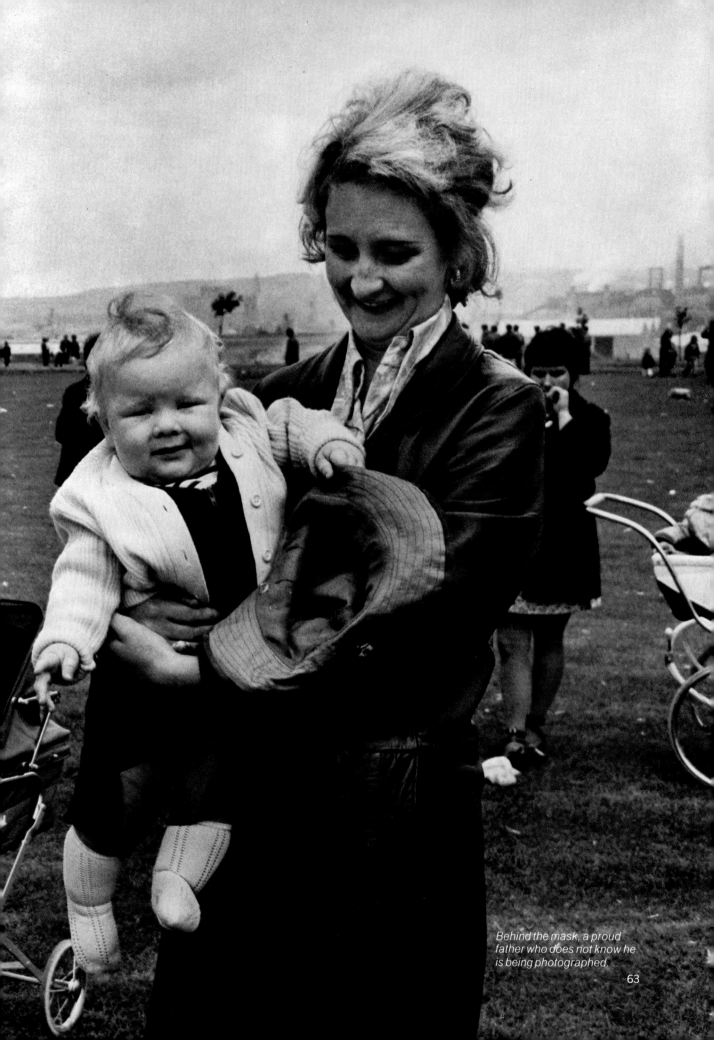

Behind the mask, a proud
father who does not know he
is being photographed.

63

care that her pictures are not destroyed prematurely.

Several years later, she translated what she had seen that afternoon in Southern Italy to another place, a movie set. Mary Ellen was on assignment to photograph Arlo Guthrie on location for his film, *Alice's Restaurant.* Again, working in natural light, she saw colors streaming through church windows. She wanted the play of hues to suggest the strange generation that Valli had portended and Guthrie was part of. She had him sit down, then lift his head so that light from the stained glass framed it. (Pages 10-11.) The kaleidoscopic effect of glowing colors falling on Guthrie brought back the charm and innocence of another afternoon, in Italy: Valli, necklaces of amber and silver surrounding her neck, tentatively offering an orange tiger lily like an exotic orchid to the young woman taking her picture.

Summing up current events

Mary Ellen's greatest gift is to work with people, even in situations where extreme events are happening. As a photojournalist, she sees events through people, and she works with them from a viewpoint that is often ironic. Irony, for her, means using elements in a situation to point out some contrast between apparent meaning and real meaning.

It isn't satire, which exposes and ridicules a vice. Mary Ellen's irony is both funny and sad, a mixed condition most humans live with.

Even in a civil war, her camera can narrow down a nation's violence to a particular human instance by exploring, say, the relationships in a family.

What goes through the mind of a photojournalist on a grey, overcast day in Belfast when the rest of the press has gone and she finds herself alone in the midst of a potentially violent situation? Does she worry about physical harm? The loss of her camera?

Some Protestant militants from the Ulster Defense Alliance were openly hostile to her; a woman alone had no business there. The speeches were over, the UDA's display of grim threats against the Catholic IRA had been presented for interested members of the press. She wondered if they were going to take her film away; it was certainly obvious that they considered her an interloper. She began to wander around, paying ostentatious attention to mothers and their children, trying to blend in, a nervous smile flickering on and off.

She saw a young woman bending over her baby. Mary Ellen's smile broadened. She carefully walked over and bent down, looking into the perambulator. "My, what an adorable child," she exclaimed. The woman

smiled back and asked Mary Ellen if she had any of her own.

"No . . . " Mary Ellen's voice trailed off, feigning regret. "But she's so cute. It is a she, isn't it?" They began to talk about the child. "Would you mind if I took your picture? And the baby's?"

Mary Ellen had already noticed the woman's husband, ski-masked to avoid recognition, off to one side. She also knew she still had a 28mm lens on her Leica M-4 from earlier in the day. There was a good chance the man wouldn't know how much space the lens took in. If she could just seem to concentrate on getting the obvious picture, she could get a stunning bonus. She didn't have time to worry about exposure or careful focusing; the 28mm has good depth of field, and would keep everything in focus.

As Mary Ellen positioned herself behind the viewfinder, she knew the exhilaration of the chase; her prey was right there, and she continued to coo to the baby and mother, her attention seemingly focused on them, while the wide-angle swept in the husband. The two women exchanged a few more pleasantries, and Mary Ellen walked off, gingerly, through the last remnants of the rally, knowing she had recorded a family portrait that wouldn't be found inside a silver frame in a living room. Behind the mask of the militant was a proud father, but Mary Ellen and he had barely spoken. (Pages 62-63.)

On the other side of the ocean, in Appalachia, Mary Ellen created another family portrait. Again, her ability to work with people produced a picture that was both planned and spontaneous, and the key to this picture, as in the Irish portrait, was the woman.

On assignment for *Ms.* magazine, as she had been in Ireland, she spent a morning photographing a mountain couple and their cabin in Harlan, Kentucky. Their neighbors came down to watch the city woman take pictures. The husband was intrigued with Mary Ellen's camera, and when she had finished shooting the house, he came over and asked to have his picture taken with his gun. She noticed he carried it like a prized possession and as he climbed easily into the crotch of the tree to crouch there, cradling the weapon, she knew the image in her viewfinder would make a succinct statement about the life of a mountain person. He posed without direction as she obligingly took pictures, and stayed up in the tree when she went over to his wife and made a few pictures of her. Since a rapport seemed to be developing, Mary Ellen suggested, "Let me do some pictures of you together." The wife talked to Mary Ellen as they walked together over to the tree where her husband was watching. Mary Ellen considered asking the woman to climb up with her husband, but when she realized that neither of them was aware he was holding the gun at his wife's head, Mary Ellen knew instantly that this was the picture she wanted. She calculated the light, which became slightly hazy as the sun moved behind some clouds, and snapped the shutter.

"I realized she didn't even look at him when he was holding the gun at her head. There were two people living very happily together, but it looked to me as if they were totally

Mary Ellen was photographing women of Appalachia when a husband moved into the picture with his favorite possession.

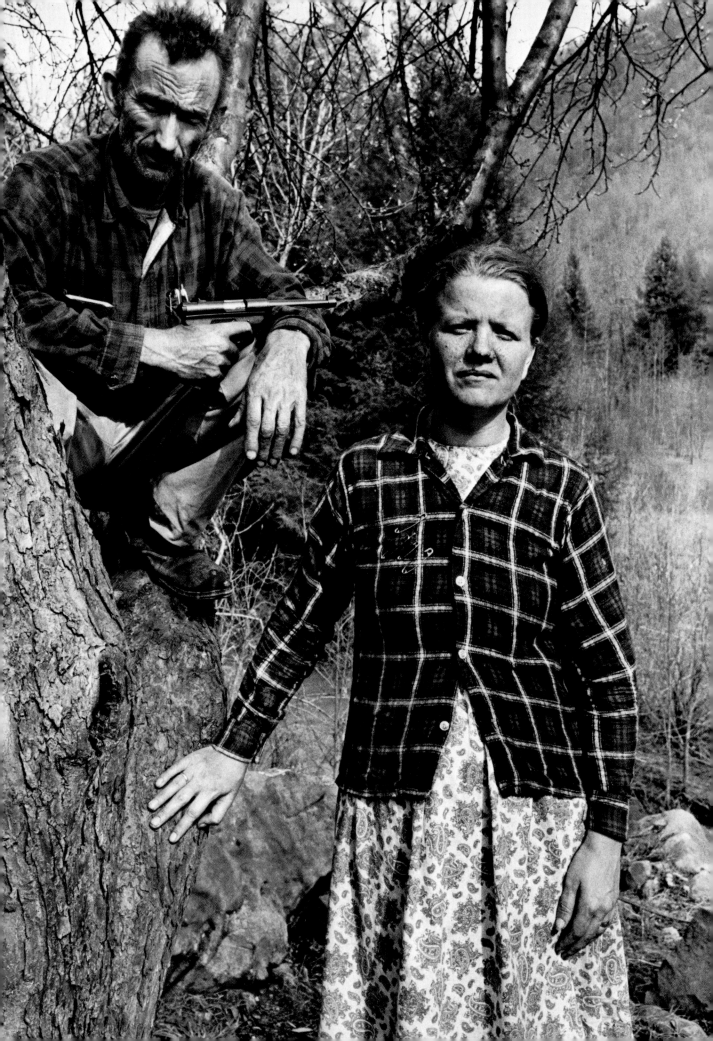

unaware of each other's personalities. He loves his gun. The relationship of those people living up in the hills with no money, eating off cooking fires, is exactly the same as a couple living in Miami Beach or Beverly Hills, anywhere that's middle class. They don't really relate to each other most of the time and there isn't much awareness of anyone around them. That could happen anyplace, Appalachia or here. Two people living together and unconnected. You know, they probably get along much better than most people."

Again, the 35mm lens on her Leica M4 allowed her to capture the texture of their faces without sacrificing important context. The stark branches behind them reinforced the large tree in the foreground. All of these elements combined had an excitement, a contrast that good photographic journalism almost always contains: "Find the situation. Put them in it. You have to put a little zing in the picture. Of course the excitement was already there. It just needed composition."

Whether **Mary Ellen is doing a story on Appalachia or an essay on the Women's Army Corps,** her first concern is a straight-on, direct kind of coverage. What she looked for in a diverse group of women with one common denominator—the Army—was a study of the quality of their lives as WACs. To get it, she overcame a number of

problems that were more tactical than technical.

When they arrived at Ft. McClellan, Alabama, writer B.J. Phillips and Mary Ellen discovered they would not be allowed to live at the training center. For 10 days, the two women commuted between the

ON LOCATION WITH THE

W★A★C★S

By B. J. Phillips

Despite all the talk about cutting out the hassles and making the armed forces an attractive career, training is still based on trial by fire.

Photographs by Mary Ellen Mark

base and a motel a couple of miles down the road. As they arrived on the reservation each morning, an officer was immediately assigned to them to point out items of interest and make sure they didn't see too much.

Mary Ellen spent the first two days observing, trying to sort faces and impressions. She had her camera with her, but didn't use it. By the third day she had an idea of the routine the WACs followed. Late that night, she and B.J. returned to their motel rooms, discussed what they had seen and what they wanted to portray.

Mary Ellen likes working

with a writer. "We can talk at the end of a day...say, did you notice this or that? B.J. and I worked terrifically together, really living it and laughing about it, getting terribly involved and nervous about how we were doing it together. It's less lonely, too." The

difficulties of surveillance created a bond; they were more determined than ever to depict as many aspects of the trainees' lives as possible. Involvement with the story and interplay between writer and photographer reinforced their tenacity, a key word in photojournalism.

As their enthusiasm and involvement continued to develop, they were gradually accepted. Mary Ellen's vulnerable demeanor broke down much of the officers' initial resistance, and although there were still places that were off limits, the trainees responded with cautious eagerness. Mary Ellen let

them know that "we didn't want to put them down. We tried to see the funny side of it and sometimes the lonely side, to break through to the people and see what their life was really like." The trainees were mainly 19-year-olds from a variety of lower-middle-class backgrounds who had joined the WAC to step up in the world. "Some were ex-Girl Scout types, kind of tough, sporty, and some were young girls from poor families who couldn't go to college, they didn't have the money, so they were trying to do what I'm trying to do in a way—see the world." What Mary Ellen brought to her photographs was an ability to identify with the women in a way that didn't objectify them.

She attended the graduation of an officer, a woman with a college degree, looking for the diversity that reflected the range of the WAC. This woman, in her mid-twenties a bit older than the enlisted persons, could sum up part of that variety she sought. Using a Leica with a 35mm lens, Mary Ellen came in close to emphasize the figures of the officer and her aunt who had come down for the occasion. She focused on the proud faces and made a snapshot of graduation, where everything was at its moment of perfection; the uniform a perfect fit, the distance magically closed between the women.

During camouflage maneuvers, the trainees had to improvise bonnets of foliage to conceal their helmets. Mary Ellen caught the humor of the moment by focusing in close, and as she opened the lens, the depth of field diminished, blurring the background that had provided the camouflage. That evening, back at the base, she used the same lens—her favorite

Graduation day at Fort McClellan.

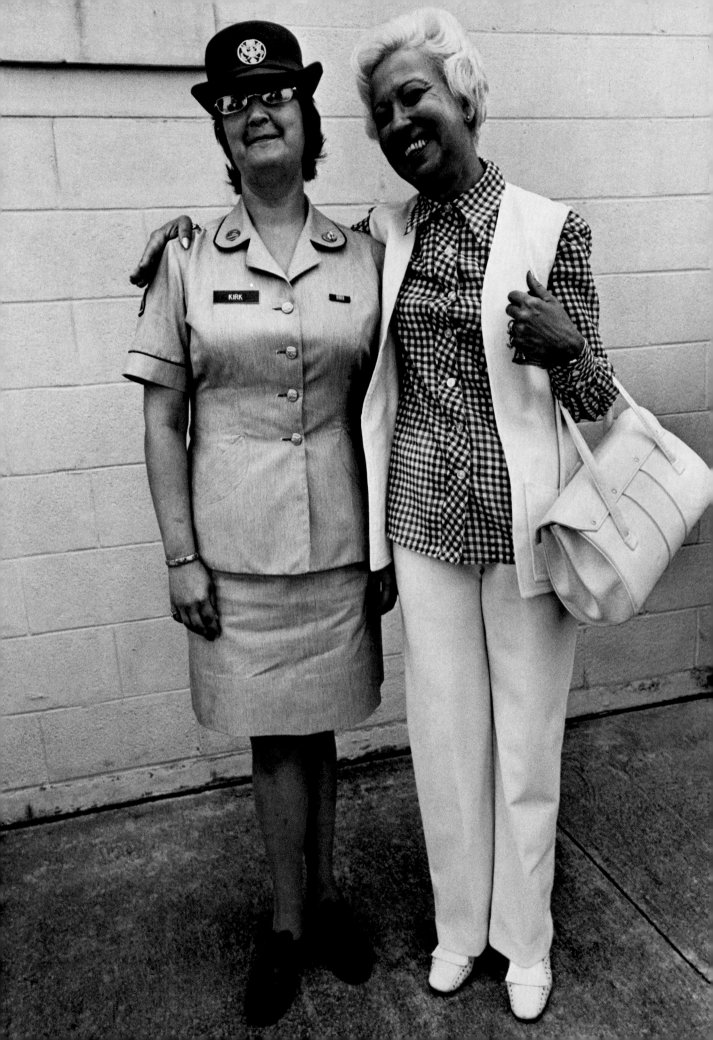

35mm—to impose distance. A WAC sat isolated on her bed in the austere barracks; Mary Ellen fastened on the loneliness of the moment with everything neat and tidy, nothing out of place from the woman's hair to her bed with its foreign smoothness.

"I tried to get in every aspect I possibly could. If they had allowed me to go into the bathrooms with them, I would have."

There were moments of play. Women with their masks on—gas masks this time—clowned for their faceless portraits. Their pose revealed not only Mary Ellen's wit but her persistence.

When she saw a row of mannequins showing all the changes of WAC costume over the years, she asked the officer in charge of the WAC museum

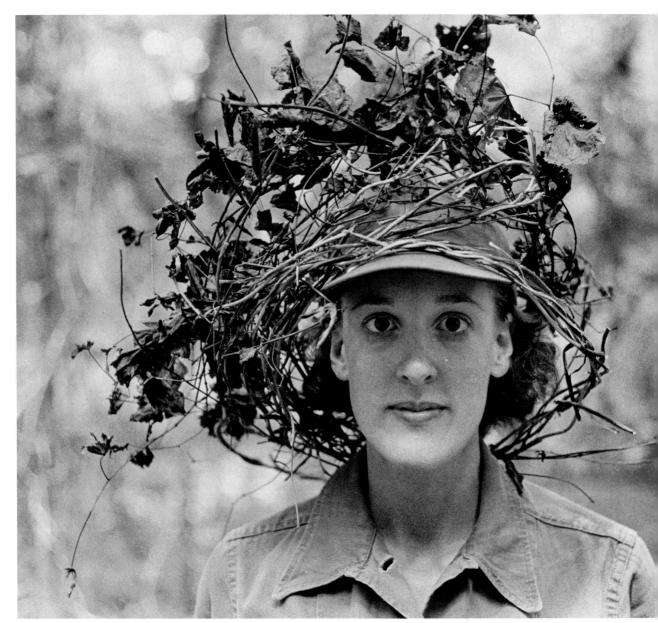

to pose with them. The woman obliged without question, but out of a planned situation, a spontaneous one arose. Irony struck Mary Ellen: "Some women in the WACs became as stiff as the mannequins in the cases. I saw her there in that instant as a statement about the sterile atmosphere, but I knew, even then, it was a lifestyle that some people choose.

She wasn't aware that she had become her uniform." Mary Ellen saw the beginning of that process, as trainees chose to stand in a bus to avoid getting their uniforms wrinkled. "It's the kind of thing I couldn't live through; the last thing in the world I could do would be a WAC. Neat, tidy, everything fixed." Although separate, she was totally involved in the story.

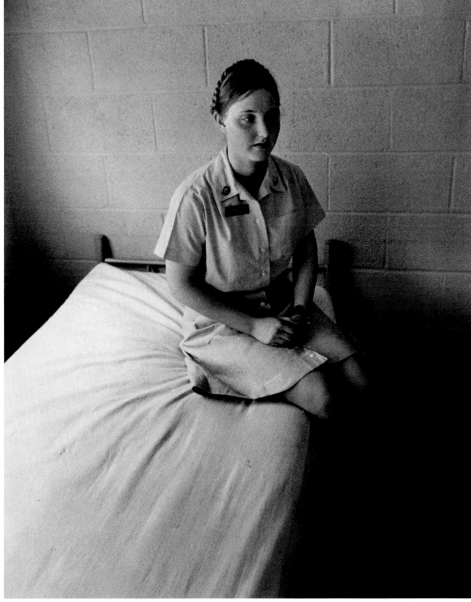

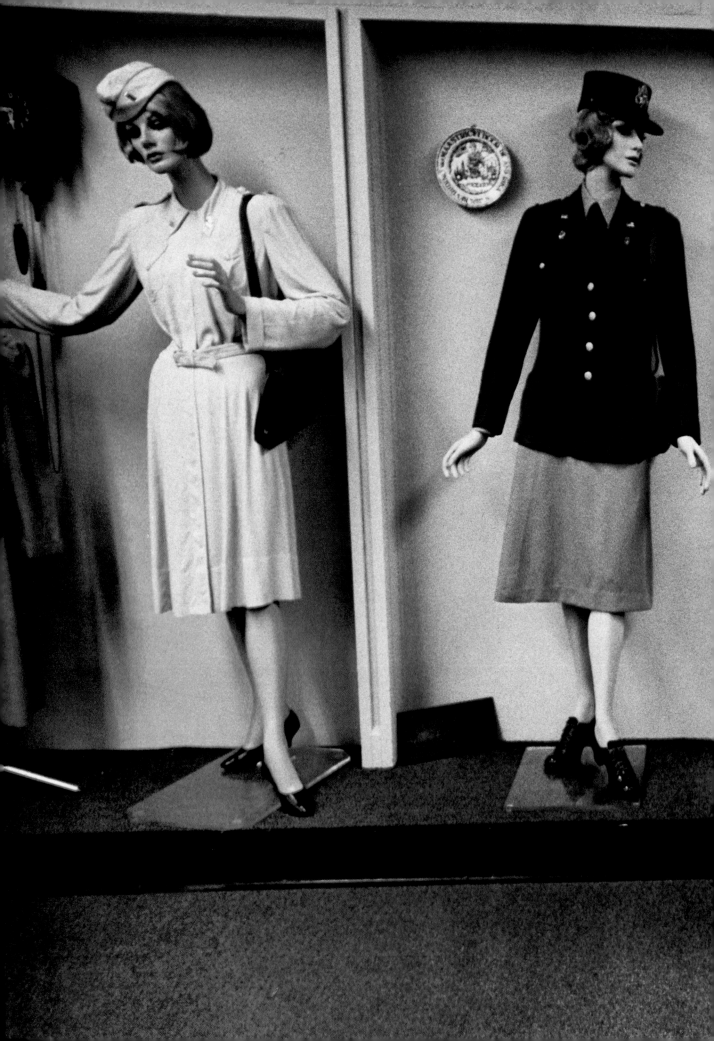

Reporting intimate dramas

It is not often that a photographer who attends the birth of a friend's child manages to produce more than a personal folio of snapshots. Mary Ellen had known Donald Sutherland for four years. She had photographed him before, and he felt comfortable whenever she worked around him in her intense, invisible way. Like many actors, Sutherland is self-aware to the point of being quite self-conscious, but he remembers the first time Mary Ellen's unobtrusiveness caused him to laugh uproariously. They were in a little boat; she sat in the bow and took pictures. It was raining hard and Sutherland did just what she wanted. He forgot she was there. As the rain began to collect in the bottom, sloshing over their feet, he became aware of her only when she said from behind the camera in a tiny voice, "Donald, are we going to drown?"

When Mary Ellen arrived in California in 1974 to work on *The Day of the Locust,* in which Sutherland was starring, he told her that he and Francine Rachette were going to have a baby, then added as an afterthought, "It would be terrific if you could photograph the birth."

Photographing a birth, or any dramatic event whose outcome changes

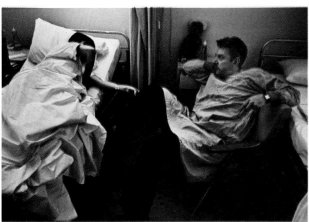

the lives of human beings, poses particular problems for a photojournalist. Her first obligation is to record what happens. That's why she is there. But what does she do if trouble starts? Does she put her camera down and try to help, or does she go on photographing? How much of the situation can she pre-plan or be prepared for? For a fast-moving, unrepeatable situation like this, she had to ask herself:

Should I concentrate on Donald because he's a movie star, or on Francine for the drama of birth, or on the doctor who just shows up for a minute, or on the baby emerging? She decided to try for them all.

Technically, Mary Ellen knew she would have two main problems: light and space. She would be operating in close quarters in a highly emotional situation, and realized, "After all, I was going to

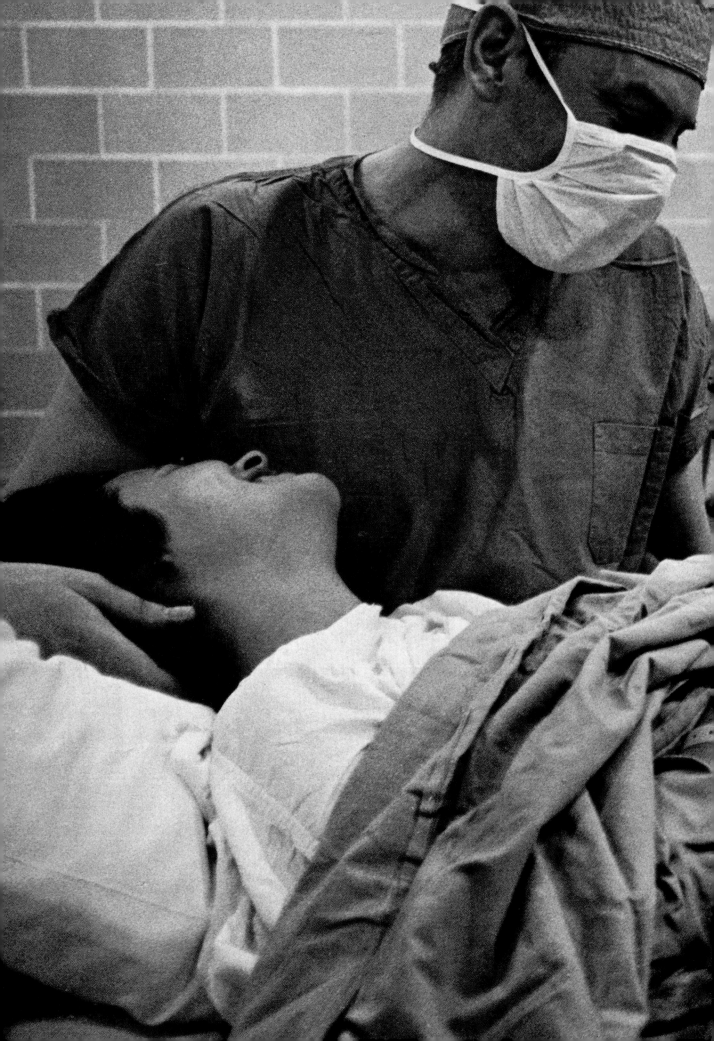

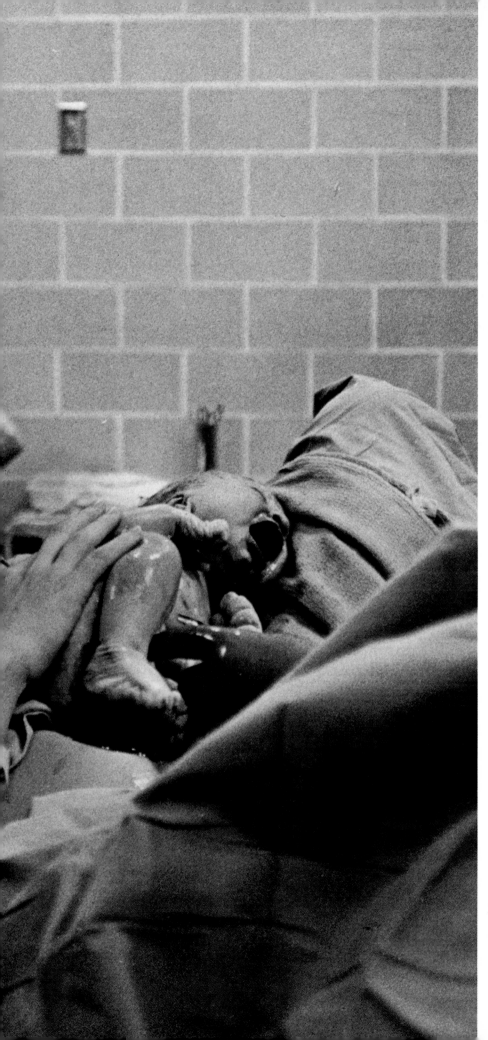

participate in the most important moment of their lives together.''

She planned her equipment carefully: two Leicas with three lenses, a 28mm and a 35mm for depth of field and width of context in the delivery room, and a 90mm for closeups. The light was going to be a problem, even with Tri-X, because Sutherland and Rachette wanted a natural childbirth in a soothingly dark room. She worked with lenses wide open. ''I didn't feel the least bit self-conscious, but I'm glad I realized beforehand I couldn't use a flash in that situation. It would have disturbed everyone. They were so caring; it was important to them. And to me.''

She couldn't hold all the elements on film, so she compensated in a way by keeping her main attention on Sutherland and Francine, depicting their intimacy and awareness. As Francine later recalled, ''I could see the doctor, Mary Ellen, the nurse, Donald. But no one could, in a sense, see me. I was really, really alone with Donald and the baby. It was a beautiful feeling, as if there were water around us all. It's too bad nobody was there to photograph Mary Ellen at the same time, because she was as full of the camera as I was full of the child.''

The long friendship with Pat Carbine continued as

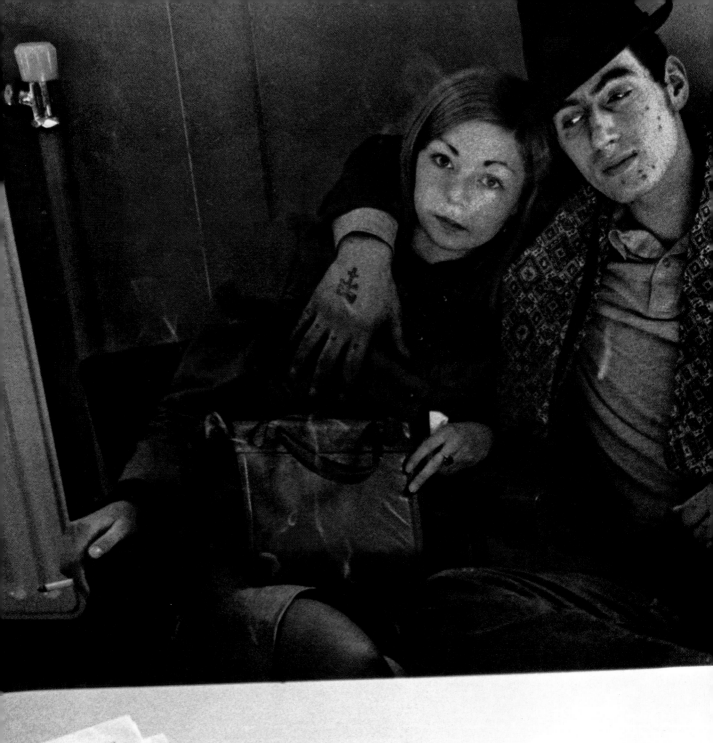

Carbine moved from *Look* to *McCall's* and then, with Gloria Steinem, started *Ms.* Stories such as the WACs and the Appalachian coverage resulted, but Mary Ellen's first big break had come before, when *Look* was still alive and Carbine sent her to London with writer Mary Simons.

The chill of winter in London was almost over, but inside a community center, in St. Clement's

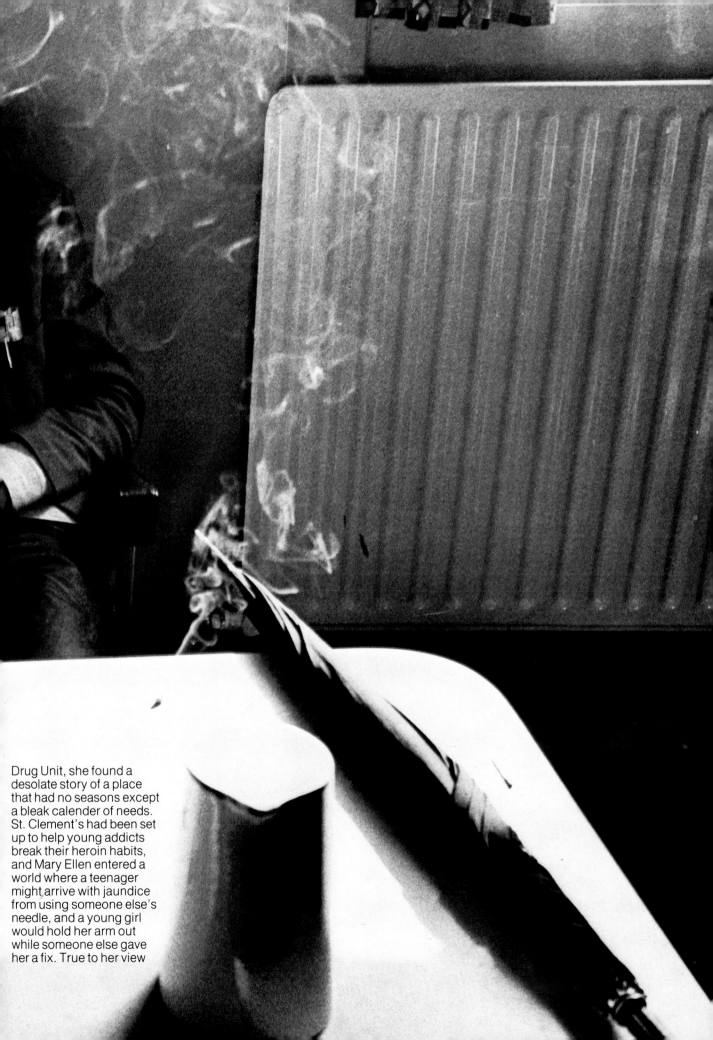

Drug Unit, she found a
desolate story of a place
that had no seasons except
a bleak calender of needs.
St. Clement's had been set
up to help young addicts
break their heroin habits,
and Mary Ellen entered a
world where a teenager
might arrive with jaundice
from using someone else's
needle, and a young girl
would hold her arm out
while someone else gave
her a fix. True to her view

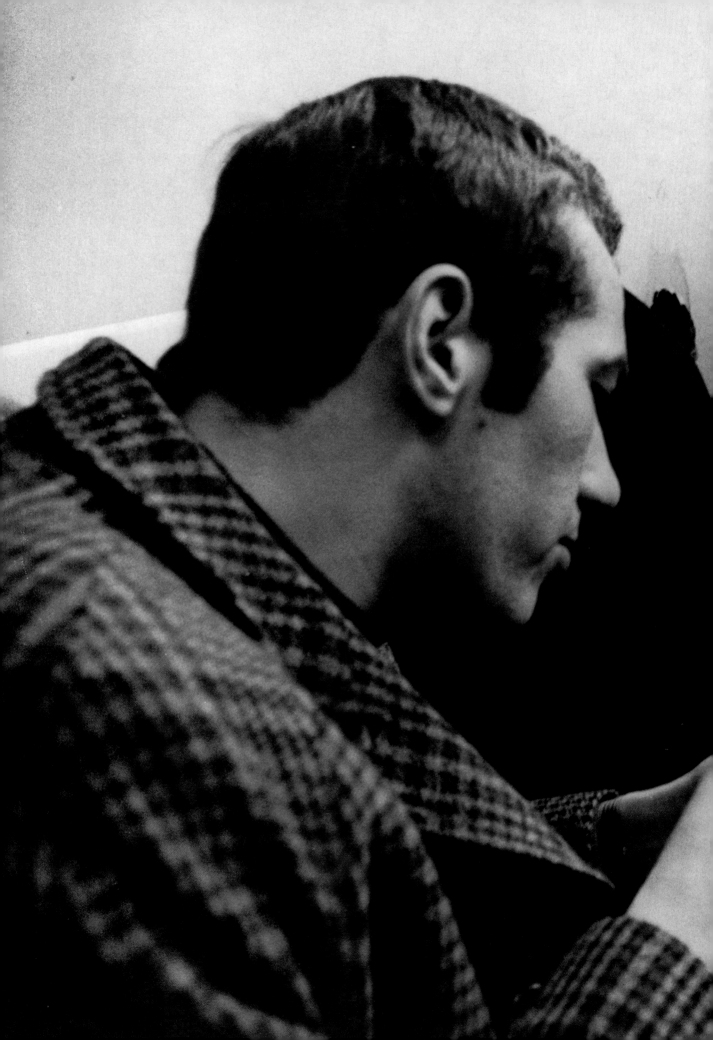

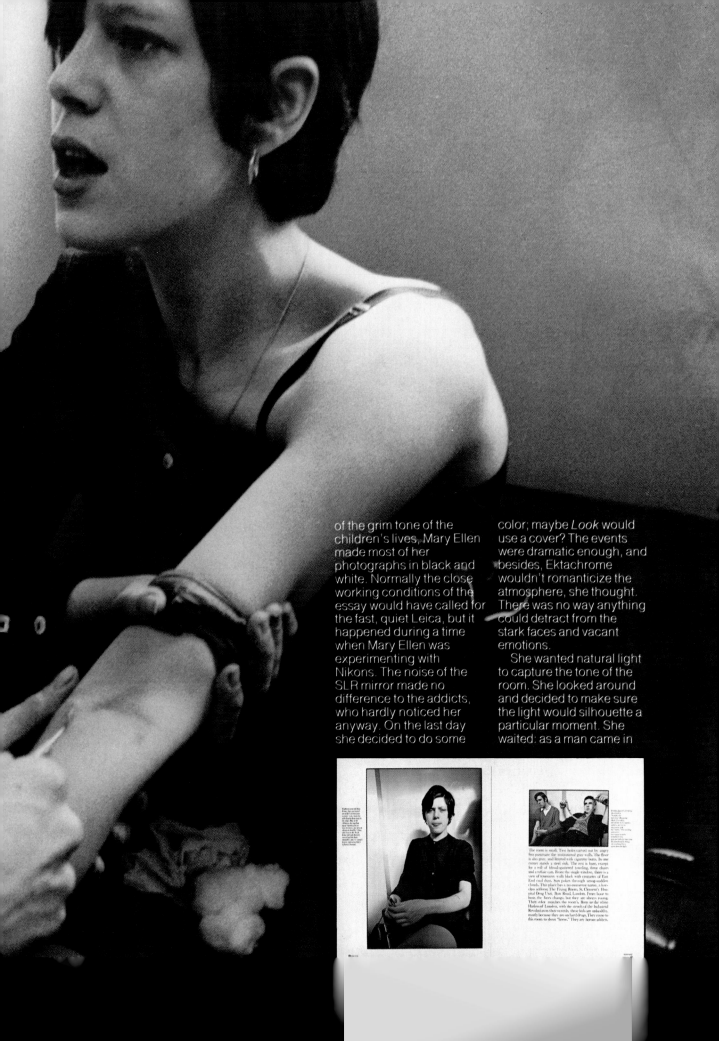

of the grim tone of the children's lives, Mary Ellen made most of her photographs in black and white. Normally the close working conditions of the essay would have called for the fast, quiet Leica, but it happened during a time when Mary Ellen was experimenting with Nikons. The noise of the SLR mirror made no difference to the addicts, who hardly noticed her anyway. On the last day she decided to do some

color; maybe *Look* would use a cover? The events were dramatic enough, and besides, Ektachrome wouldn't romanticize the atmosphere, she thought. There was no way anything could detract from the stark faces and vacant emotions.

She wanted natural light to capture the tone of the room. She looked around and decided to make sure the light would silhouette a particular moment. She waited: as a man came in

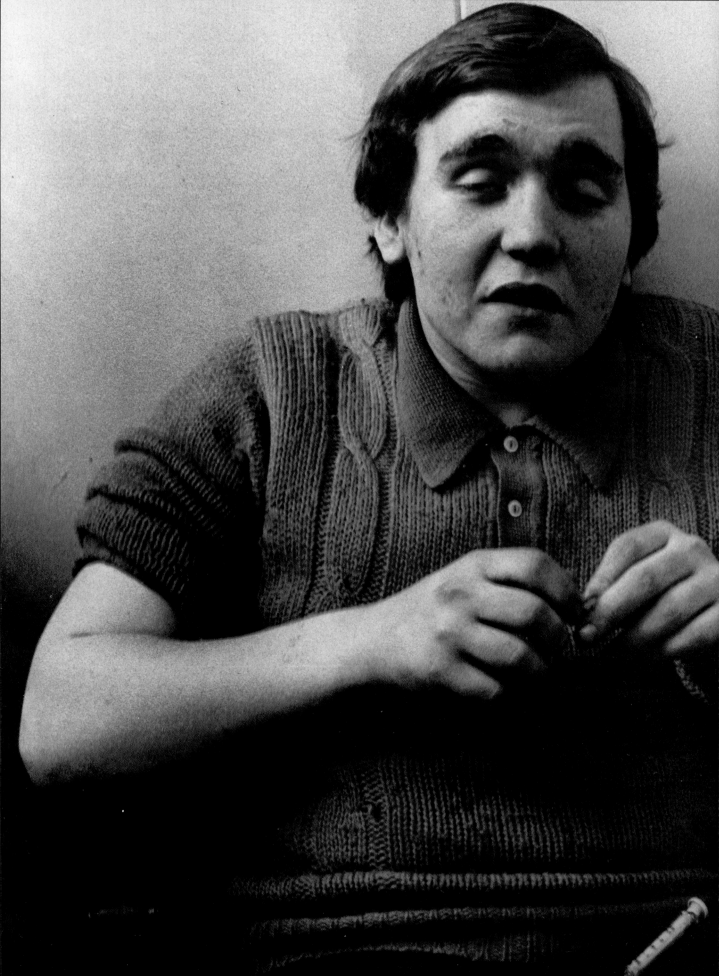

to help a girl shoot up, Mary Ellen sighted through the lens and made sure the figures stood out to increase the photographic impact. She had thought about strobe, but rejected it; the flash would have given the photographs a sharp edge somehow false to the harshness of the subject matter. No, its intrusion might have destroyed the effect that Mary Ellen got from back lighting. She wanted an atmosphere that was chillingly real and natural at the same time it was depressingly hopeless.

There was little resistance to break down, even at the beginning. The addicts didn't care about her. The thing they related to was the needle. Both women found themselves feeling isolated but emotionally involved at the same time. What if an addict went berserk, or tried to attack them? What if someone actually overdosed in front of Mary Ellen's eyes? I wonder what I'd do, she thought . . . put my camera down? Or take the picture, and then put it down?

The women took certain precautions. They were careful not to disclose to the addicts where they were staying, but at the same time were honest with them about what they wanted to show.

Mary Ellen relied on her usual 35mm lens to point up the ironic distance between one young man and a young woman who sat leaning against him. (Pages 76-77.) Highlighting emphasized their isolation, and her wide-angle lens made it complete. Only the woman had a partial awareness of the camera; the man had just taken a fix and was aware of nothing outside himself. The photojournalist in Mary Ellen took advantage of that fact, becoming the

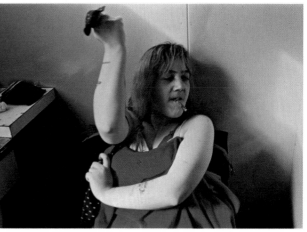

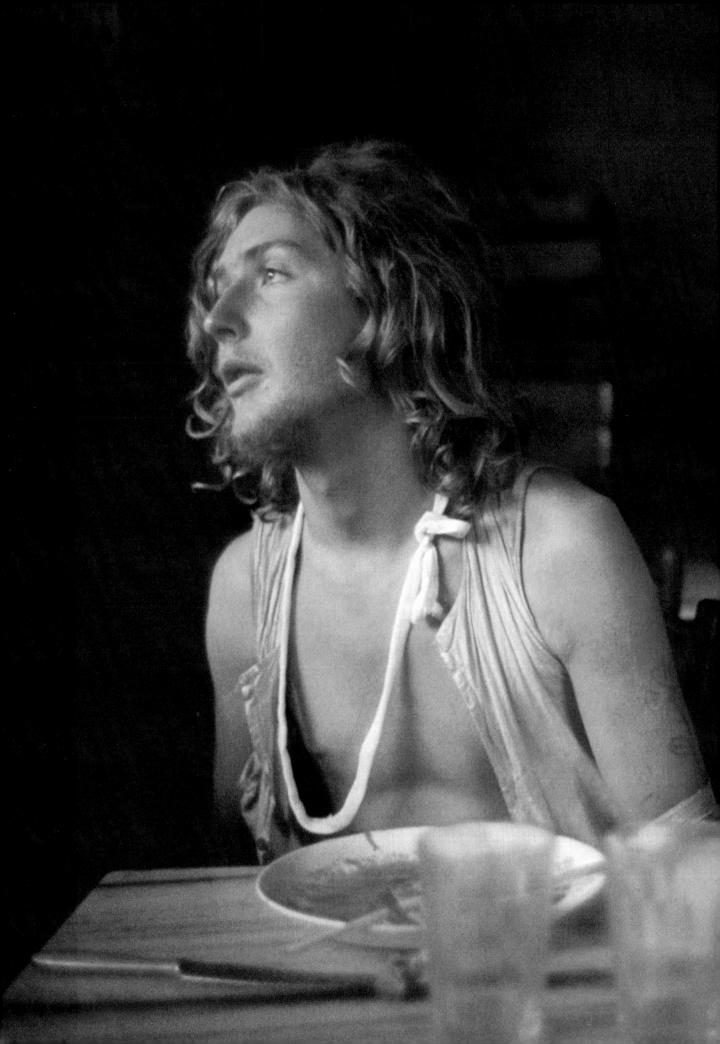

invisible recorder of an unstaged event.

Many pictures shot in the "fixing room" presented their own problems. The space was so small that it was hard to focus a camera there. But she had to have those pictures for the drama they revealed: at the moment people were shooting up, everything was written on their faces. "They didn't mind us being there; they were pretty exhibitionistic. There were other pictures I didn't take. Now, I would. These pictures weren't meant to say anything but how freaked out and how horrible it all can be."

Her empathy extended beyond the subjects. She said to her co-worker, Mary

Discovering social change

When a photographer has a love affair with a country, it is like any other love affair—irrational. For Mary Ellen, India was this kind of experience. She

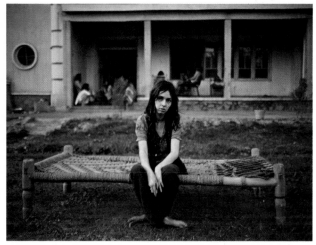

Simons, "I think it's tougher for you than for me. At least I have the camera between me and them. You have nothing."

The camera is always there, destroying and imposing distance. Sometimes the subject matter of the photograph is the inner contact between Mary Ellen and the people she photographs. Her need to photograph and document makes her usually able to override personal feelings toward a situation. She *must* photograph—and what emerges is not simply a face or a figure, but understanding.

went there twice for two months each time on assignment for *Paris-Match* to record the migration of young Americans and Europeans away from Western culture.

She began to track them down as they searched for drugs, adventure, spiritualism or a simple vacation, and as she recorded incident after incident on film, an overall theme emerged. They all sought something their own culture denied them.

On the street in Bombay, she saw a young man, dazed and suffering from a huge infection on his arm. She took him to a

little restaurant to buy him food; "He was so wiped out that he just looked out the window, vague and dreaming." Not wanting to change lenses or break the mood, she opened the 35mm lens she had on her camera to its widest aperture, letting the reality of the foreground go out of focus to emphasize the feeling of the moment.

At a beach in Goa, very late one afternoon, a young Swedish couple she had been photographing sat on their red carpet and the man began playing a portable organ they had carried with them. Mary Ellen again opened the 35mm lens wide to catch the last light as the woman looked off into the remote afternoon. She captured

the poignant distance between the man and woman and emphasized the space around them in the width of her frame. (Pages 84-85.)

On another waterfront, on another late afternoon, she saw a young man walking, playing his flute, wrapped in the dress and mannerisms of the culture he wanted to be part of. The irony was that he couldn't relate to anyone.

The women, the men, dispossessed, "are all self-involved in the same sense that I saw in England when I did the heroin story. Where are they going to get their next fix? They don't think about their fellow man or anyone. It's sad. They can't really be close, like Donald and Francine. I have to show both sides."

For Mary Ellen Mark and Annie Leibovitz, the chase, the search to discover the inside and outside of their world, involves far more than just technique. They are both more interested in getting the image on the film than in worrying about apertures or focal lengths. Equipment for them is to be mastered because it helps them capture the moment.

If Mary Ellen and Annie seem a far cry from the stereotyped image of the photojournalist laden with technical knowledge and bags of equipment, their world still revolves around the chase, and they represent an evolution in communication. Because space is less plentiful than it was in the days when *Look, Life,* and other big picture magazines were operating, they publish fewer pictures but demand much of those they take, knowing they must sum up an event succinctly, accurately, and dramatically. They compete with men on an equal basis in a profession that has, with few exceptions, been traditionally male. Events seldom care about gender.

Perhaps it would be wrong to say Annie Leibovitz and Mary Ellen Mark are photojournalists *despite* being women, because they share with the best male photographers some qualities that are traditionally female: compassion, sensitivity and intuition. They also represent complete commitment. Photojournalism is their life. They have both made a conscious decision to present the world around them as a continuing series of visual events, a human involvement—to see, to bear witness, and to share.

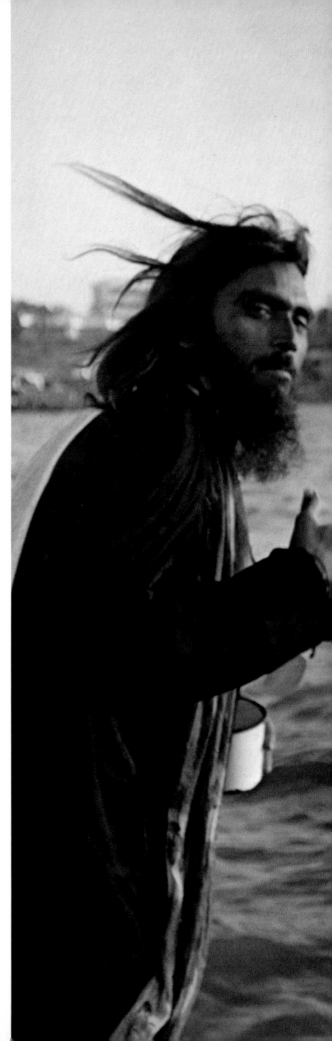

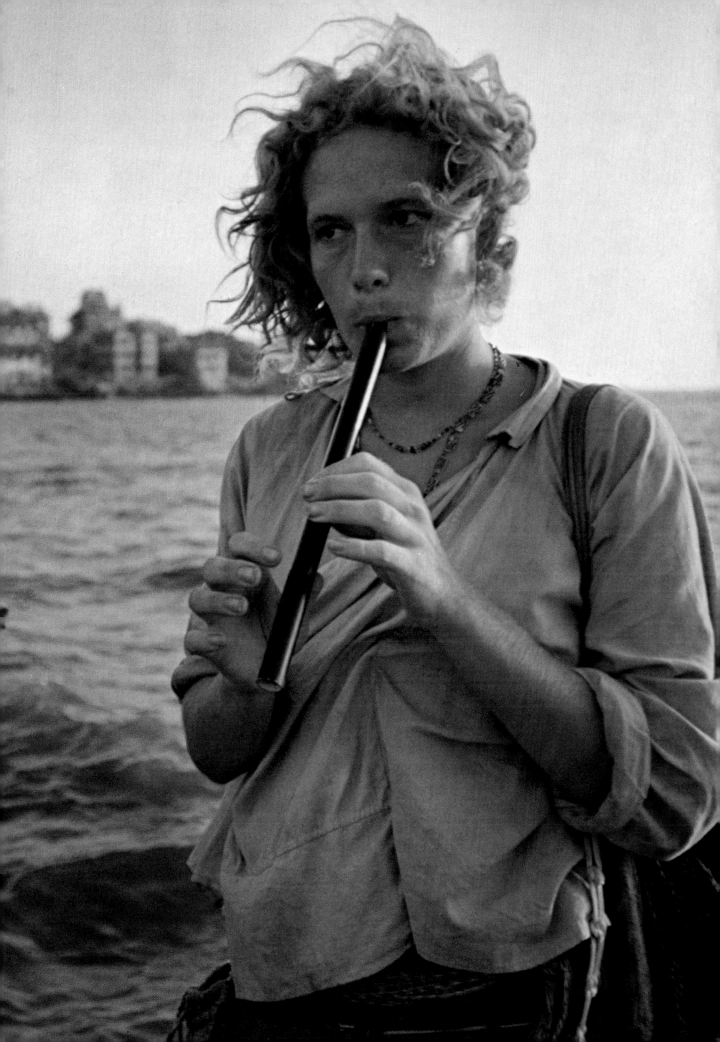

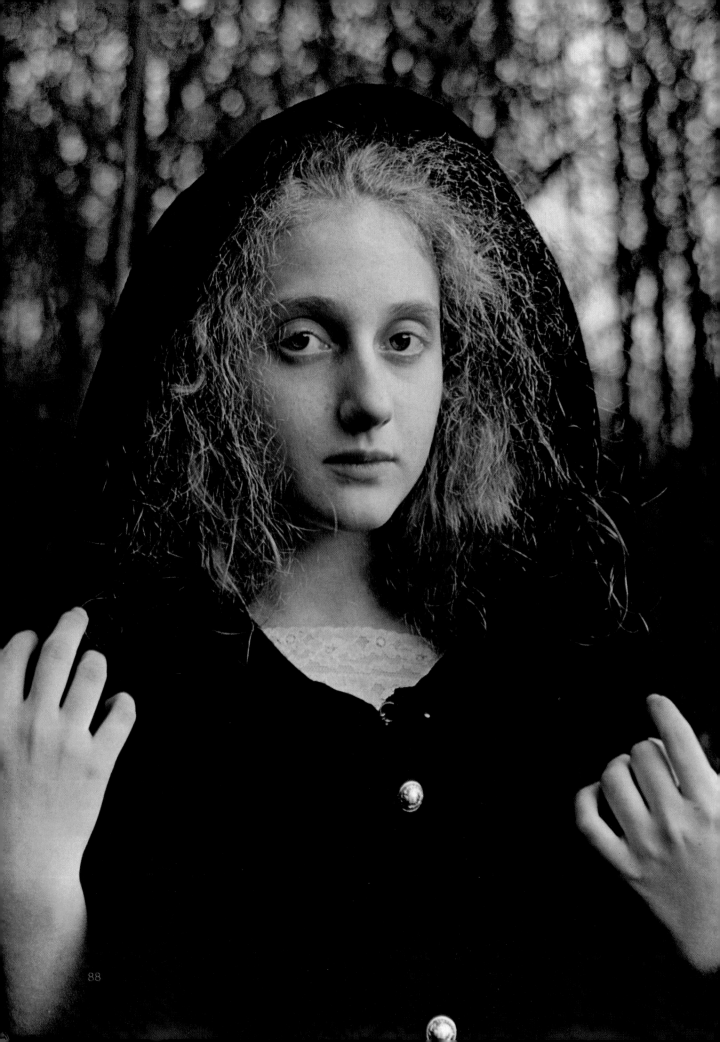

Technical section
Tools of the photojournalist

Photography, like any form of visual art, is primarily a product of the artist's intellect and sensibilities, and only secondarily a matter of equipment. But it goes without saying that a photojournalist who has mastered the camera and its accessories can translate experiences into pictures more freely than one who has not. Just as a sculptor depends on finely honed blades and a painter on carefully shaped brushes, a photojournalist needs equipment equal to the demands of his or her work.

Professionals and amateurs alike have access to the same types of cameras and lenses that Mary Ellen Mark and Annie Leibovitz use. With that in mind, we can first explore the usefulness of various kinds of equipment to a photojournalist, then add details about the ways Mark and Leibovitz used them to shoot some of the pictures in this book.

Mark and Leibovitz are inheritors of a tradition in photojournalism begun by predecessors like Berenice Abbott, Dorothea Lange and Margaret Bourke-White, pioneers who showed in the Twenties and Thirties that men were not the only creatures equal to the rigors of photojournalism. Like Leibo-

Portrait of a friend, Carol Kane, by Mary Ellen Mark.

vitz and Mark, they were photographers first and feminists second (if at all), but their work made sure that visual commentary about the world would no longer be exclusively male.

Abbott, Lange and Bourke-White began with the professional camera of their time, the large view camera. Although they later used more portable cameras as they became available—the twin-lens 2¼ square reflex, the 3¼x4¼ single-lens reflex, the 4x5 press camera—the technical grounding they got from view cameras remained a coveted asset throughout their careers. Bourke-White eventually worked with almost every type of professional camera made, including the Fairchild aerial, the 4x5 Combat Graphic and the Plaubel Makina. Abbott was so well versed in the technical aspects of photography that two of her books, *The View Camera Made Simple* and the *New Guide to Better Photography,* have remained classics despite the passage of years.

With the simplification of photographic hardware that resulted from advanced design of smaller and newer cameras, the ranks of outstanding women practicing photojournalism began to swell. The names of Eve Arnold, Charlotte Brooks, Eileen Darby, Tana Hoban, Lisa Larsen, Nina Leen, Inge Morath, Barbara Morgan, Ruth Orkin, Marilyn Silverstone, Suzanne Szasz and Ylla, to name only a few, became familiar to magazine and newspaper readers around the world.

It is in this company that Mark and Leibovitz have established themselves as two of the best of the pure photojournalists. At a time when large-format picture magazines such as *Look* and *Life* have folded and many of the top names in photography's most glamorous and adventurous specialty have moved into more lucrative advertising and industrial work, Mark and Leibovitz continue to

chronicle faces and events of current interest.

In doing so, they have remained loyal to the one film format that has become indispensable to modern photojournalism—35mm.

Aside from slight differences in design—the placement of knobs, levers and accessories—all of the hundred-odd 35mm cameras on the market today can be classified as one of two types, the *rangefinder* camera and the *single-lens reflex* (SLR).

Rangefinder. Since the appearance of the Leica in 1925, rangefinder cameras have been favorite tools of the photojournalist. Viewing and focusing are done through a single window in the top left side of the body as the photographer sees it from behind the camera. In

cameras with focal-plane shutters, the sole function of the lens is to transmit light to the film plane. On other models, the lens contains within its barrel a "between-the-lens" shutter made of overlapping metal plates that spring open and shut like the iris of the eye. Since viewing and focusing both occur through the separate clear window, rather than through the optical system of the lens, the photographer can focus and frame a subject quickly and easily in low-light situations that sometimes present difficulties with through-the-lens viewing systems.

Single-lens reflex. The principle of through-the-lens viewing that underlies the SLR system is older than photography itself. The *camera obscura* (literally, "dark chamber" in Italian) in which Nicéphore Niépce made the world's first photograph in 1826 was an artist's drawing

aid that gathered light through a lens and cast it, via a mirror, onto a frosted viewing screen on top. Arabian scientists are known to have played with the *camera obscura*—lensless and not very portable, since it consisted of a tent with a small hole in one wall—as early as the 11th century. At any rate, SLR cameras in the 35mm format went into manufacture in the 1930's. Not until the late 1950's, however, did improvements—an instant-return mirror, an automatic diaphragm, and a pentaprism viewfinder—make the 35mm SLR attractive to both professionals and amateurs. To those unaccustomed to through-the-lens viewing, the new SLRs brought a new experience: the excitement of selectively controlling areas of the picture that they wanted in or out of focus and seeing, through the lens, the exact image that would soon be on the film. Photographers in general, including many photojournalists, began to add these new cameras to their equipment inventories.

The popularity of the SLRs became so great that many major manufacturers like Zeiss, Nippon Kogaku and Canon abandoned a good part of their rangefinder lines to put their efforts into single-lens reflexes. Today E. Leitz, originator of the 35mm camera, is the only manufacturer to offer a really sophisticated rangefinder camera, the Leica. And even Leitz hedges its bet by producing the elegant but extremely expensive Leicaflex, a camera designed along SLR principles.

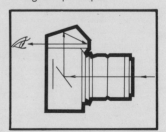

The choice between a rangefinder and an SLR was the first important decision that Mary Ellen Mark and Annie Leibovitz had to make.

Mark's style of photography not only prompts her use of the rangefinder, but is undoubtedly influenced by it. Her pictures often have that sense of immediacy, of action interrupted, that is the special result of shooting

Leica M5

with the quiet, unobtrusive rangefinder system. She also finds a rangefinder camera faster to operate than an SLR, and slightly lighter—an advantage when she is carrying four cameras, as she often does on assignment. She equips her Leicas with the shorter focal-length wide-angle lenses, and carries one Nikon on which she uses a Micro-Nikkor 55mm lens and an 80-200mm zoom.

Leibovitz, on the other hand, is ideally suited for the only type of camera she uses, the SLR. She usually carries three Nikons on assignment, one with a motor.

Nikon F2 With Motor

Slightly larger than a rangefinder camera with its hooded pentaprism and its greater mass to accommodate parts like the swinging mirror, the SLR is patently more awkward and menacing-looking than the rangefinder. And it is louder. The mirror pivoting out of the way for the exposure makes a distinct noise as it snaps against a cushioned stop. To Leibovitz, the advantage of the SLR is that, until the split second of exposure, the photographer's eye sees precisely what will register

on film. There are no complex calculations in composing and focusing. What you see is what you're going to get, and this is an asset that Leibovitz requires, working as she does toward a previsualized image with subjects who are usually under her direction.

LENSES

Both Mark's Leicas and Leibovitz's Nikons provide the versatility that comes with interchangeable lenses. Why not use some rangefinder camera other than the Leica? One reason, for a professional, is that few of today's rangefinder cameras except the Leica come with removable lenses, so they limit a user to the lens that one buys with the camera.

Cameras are usually displayed in stores with a "normal" lens attached. The normal lens, so-called because it approximates the angle of view and depth perception of the human eye, falls in the 45mm-55mm focal-length range for the cameras Mark and Leibovitz use. Wide-angle lenses are those with a focal length of 35mm or shorter, while telephoto lenses can measure from 80mm to 2000mm.

Obviously, the ability to change one's visual perspective provides a photographer with great control over the presentation of the subject. The wide-angle extends the periphery of normal sight, encompassing the subject's surroundings. The telephoto, on the other hand, will "zero in" on the subject, narrowing the natural angle of view and compressing perspective. Both wide-angle and telephoto lenses, of course, impose some sacrifice of the natural appearance of the subject. The optical curvature of the wide-angle tends to "pull" subjects away from the center of the lens toward the corners of the film frame. As a telephoto compresses distances, it tends to push everything together, giving the shots a distinct "flat" look.

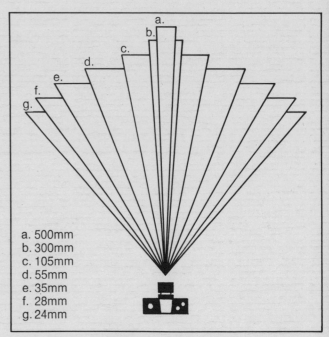

a. 500mm
b. 300mm
c. 105mm
d. 55mm
e. 35mm
f. 28mm
g. 24mm

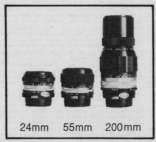

24mm 55mm 200mm

Another extremely useful auxiliary lens, particularly well suited to the photojournalist, is the zoom lens. A much more complicated bit of optical science than either wide-angles or telephotos, the zoom allows a photographer access to several focal lengths without changing lenses—one need simply extend or shorten the barrel of the lens. For example, the 80-200mm zoom lens that Mark uses on her Nikon can cover the full figure of a six-foot person at 15 feet, but zooming in allows her to fill the entire frame with just head and shoulders without changing lenses or altering camera position.

Which lens would Mark and Leibovitz keep if they were limited to just one? Interestingly enough, they both say their choice would be a 35mm. Mark's reasoning is, "It's right for my vision. It's the lens I'm most comfortable with." Leibovitz's an-

swer provided an insight into her photographic philosophy: "I look for images that are a bit different—a little surreal. The normal lens is a challenge to me: I have to work to avoid getting normal-looking pictures. My favorite lens is the 28mm because it gives me a different perspective with a minimum of distortions. But if I were stuck with just one lens, it would be the 35mm because it would be safer for all around use."

Implicit in their answers, of course, is another advantage. The shorter focal-length lenses provide a greater depth of field compared to longer lenses at any given aperture. This means that the user need not be as critically exact in focusing, since the depth of field will generally cover slight miscalculations.

Other professionals have claimed preferences for a slightly longer lens, like the

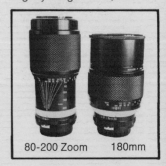

80-200 Zoom 180mm

85mm, reasoning that it provides them with larger images while working at a discreet distance from the subject. As Mark puts it, the choice of a lens is "a matter of personal vision and comfort."

The best advice for those interested in a journalistic type of photography is to select a good 35mm camera that best suits the manner in which you would like to view and work, go for lens interchangeability and plan to supplement your basic normal lens eventually with a medium wide-angle (28mm-35mm) and a medium telephoto (85mm-105mm). Keep in mind the possibility of a zoom lens that might well supplant two of the lenses mentioned above. Mark's 80-200mm zoom, for instance, is about the same size as a 180mm; she carries the one lens instead of the several telephotos Leibovitz—not a believer in zooms—prefers to carry. Don't concern yourself with extreme wide-angles or telephotos. For the amount of use that you would ordinarily get out of these lenses, they're cheaper to rent when the need occurs.

LIGHT METERS
Today it is likely that the camera you purchase will come with a built-in exposure meter. In the event that it does not, a good hand-held exposure meter should be your next purchase. Even if a meter is integrated into the body of the camera, a separate one is a practical addition to your camera bag. Light meters use selenium, cadmium sulfide (CdS), or silicon photocells to translate light into current powerful enough to move a needle across the meter's scale of light values. The latter two require an additional boost from tiny mercury batteries, which makes them practical for reading very weak light, but like all instruments powered by battery, they can run down and give inaccurate readings if the battery needs replacing. Meters using selenium pho-

toelectric cells, while lacking extreme low-light capability, will give accurate readings for all normal usage, and are not affected by a sudden exposure to very bright light. They also have the advantage of being fail-proof since they don't rely on batteries.

Regardless of the light-sensitive photocell it uses, an exposure meter is designed for reading either *incident* or *reflected* light. Most of the higher-priced models can be used either way. Exposures are calculated by reading

Incident Light Reading

Reflected Light Reading

either the light falling on the subject (incident light) or by measuring the light being reflected from the subject. Of the 100 different meters available today, approximately two-thirds are designed solely for reflected light readings. The rest can be used for either incident or reflected readings.

In addition to her regular meters, Leibovitz finds that a spotmeter is handy for shooting performers onstage at a rock concert where it is often

Spot Meter

impossible to gauge the intensity of light on the subject. Aimed and focused like a camera, these meters have an angle of acceptance of one degree, and measure the light falling on a very small area—the "spot"—of a subject. Leibovitz could have used this type of meter, instead of the camera's built-in meter and her 180mm lens, to get a reading on Mick Jagger in performance (pages 18-19). For details of how she did take the reading, see the technical notes on that picture later in this section.

To sum up: a good exposure meter will soon pay for itself as it saves you from wasting film. If you have a built-in meter on your camera, well and good. It should work for the majority of your shootings. But keep in mind that most built-in meters are somewhat indiscriminate, since they average reflected light from the highlight and shadow areas of a subject. This can be misleading if, for instance, you want details in the shadows when your subject is backlit as Jagger was when Leibovitz photo-

graphed him leaving his airplane (pages 20-21). For this reason, a supplementary handheld meter can be helpful. A handheld spotmeter, for example, is good for those distance readings and readings of areas that are impractical to meter with your on-camera unit.

FILM
Photojournalists require fast (high-sensitivity) films with good resolution, fine grain and a good degree of detail sharpness.

In black and white films, Tri-X has been a mainstay of photojournalists. In addition to its speed and high acutance, it is easily manipulated so that by varying exposure index and developing time the photographer can obtain just the degree of contrast and exposure latitude one desires. While the normal ASA of Tri-X is 400, it can be "pushed" (subjected to increased development time) to ASA 1200 without disastrous effects on image quality. In fact, at the risk of considerably increased graininess, photographers have pushed it to 3200 and 4000 on assignments.

Leibovitz rates Tri-X at ASA 800 and, by having it developed in Microdol X, obtains stepped-up contrast and a sharply defined grain pattern. Others who might rate it at ASA 1200 or ASA 1600 (the latter a two-stop push) and develop it in Acufine would discover that their negatives have picked up very little more contrast than

BLACK-AND-WHITE FILMS FOR EXISTING-LIGHT PICTURES

Film	Speed (ASA)	Graininess
VERICHROME Pan	125	Fine
PLUS-X Pan	125	Fine
TRI-X Pan	400	Very Good
2475 Recording (ESTAR-AH Base)	1000	Very Coarse
ROYAL-X Pan	1250	Medium

COLOR FILMS FOR EXISTING-LIGHT PHOTOGRAPHS

Color Film	Speed (ASA)	Type of Existing Light
High Speed EXTACHROME (Daylight)	160	Daylight, Fluorescent, or Outdoors at Night
High Speed EXTACHROME (Tungsten)	125	Tungsten or Outdoors at Night
	80	Daylight with No. 85B Filter
EKTACHROME-X	64	Daylight, Fluorescent, or Outdoors at Night
KODACHROME-64	64	Daylight, Fluorescent, or Outdoors at Night
KODACOLOR-X	80	Daylight, Tungsten, Fluorescent, or Outdoors at Night
KODACOLOR II	80	

normal and that the grain has been enlarged only imperceptibly.

Mark, preferring a slightly denser negative with a bit more contrast than normal, rates her Tri-X at the normal ASA 400 but has it processed for a one-half stop push.

Not all of the direct positive color films are subject to such manipulation—especially Leibovitz and Mark's favorite Kodachrome II, which, though relatively slow (ASA 25) was nevertheless extremely popular (before Kodak replaced it with Kodachrome 25) because of its characteristically fine resolution and saturated color. Now, Kodachrome 25 and its faster relative, Kodachrome 64, give a somewhat different tonal range than the old favorite, but you still can't push them; you rate them according to the instructions and drop them off to be processed.

On the other hand, Kodak's Ektachrome series will safely tolerate being pushed up to about 1½ stops and held back about 1 stop without any gross adverse effects.

Leibovitz was a faithful ad-herent of Kodachrome II, using it for all her color work. When the existing light is too weak for a slow emulsion, she merely adds light with a portable strobe rather than switching to a faster film. Mark is not so devoted. When lighting conditions are below the reach of Kodachrome II or 25, she works with whichever Ektachrome film is most compatible to the situation and will push High Speed Ektachrome to its limits, if necessary, before adding an artificial light source to raise the illumination level.

LIGHTS

On major assignments that involve both indoor photography and color, an oversized wooden crate accompanies Leibovitz. The box contains a 400-watt-second portable power pack, two strobe heads, two umbrellas, light stands, quartz lights and a lightweight professional-model tripod.

Leibovitz is both proud and defensive about the specially-made case and its contents. "I don't know how many times that heavy case has helped me get a picture I couldn't get any other way. I learned how to use strobes only a short time ago, and I'm still not very good at lighting with them. I take a reading with my strobemeter and pray a lot."

Mary Ellen Mark also owns a portable strobe with two heads. She admits that she uses it rarely, mainly because she hasn't had the time to become really familiar with it. More often, when extra illumination is indispensable, she will use a quartz light bounced into an umbrella reflector. With this type of equipment, she can see precisely what the light is doing and adjust it to obtain the best lighting before exposure.

The attitude of Mark and Leibovitz towards strobe-lights and even quartz-halogen lights is consistent with the photojournalist's reluctance to use anything that will alter or disturb reality.

Quartz Light

Flood Light With Reflection

Portable Strobe

Mark, whose photography hews close to the traditional school, feels much stronger about it than Leibovitz: none of her photographs in this book was aided by supplementary lighting. Leibovitz's attitude reflects more of her feeling that "reality" is what you make it, and several of her pictures in the book were made with either strobe or floodlight (Pages 6-7, 42-43, 44-45, 48-49).

Rather than blasting in an extra light source that could destroy the prevailing atmosphere of a scene, experienced photojournalists often prefer to use an old device. They bring in several #1 Photoflood bulbs of 250 watts and even one or two #2 Photofloods (500 watts). These they use to replace the normal 100-watt bulbs in the various lamps in a room. While maintaining the original lighting quality, they thus raise the illumination to a level that permits shutter speeds as high as 1/125 second on even High Speed Ektachrome Tungsten—a film, of course, that if necessary can be pushed one to two full stops.

TRIPODS

Probably one of the chief reasons that some otherwise excellent photographs begin to deteriorate when enlarged is not film or focus but a slight movement of the camera during the exposure. Camera movement can become a danger at shutter speeds as low as 1/125 second and as the shutter speed decreases from that, it becomes a major hazard.

While every photojournalist will develop a way to hold the camera steady at slow shutter speeds, it is usually some variation of the basic stance: legs spread apart with knees locked, the arms brought in tight and slightly to the front of the body with the camera cupped in the left hand and held tight in the right hand while the index finger gently but firmly depresses the shutter button.

Adaptations of this stance can include tightening up the neck strap by winding the slack around the right hand at the point where the strap meets the camera's body,

Tiltall Unique Head

until the strap is taut against the back of the neck.

By the use of such measures, photographers have found they can often work at shutter speeds as slow as ¼ second without a great sacrifice of image sharpness. Mark is confident of her hand-holding steadiness at 1/15 second.

Since photography at such slow shutter speeds is always a calculated risk, it is advisable to work with a tripod or a unipod at slow shutter speeds. Leibovitz uses the Tiltall which she packs in her wooden case along with her lighting equipment. Mark likes the tiny Leitz Tabletop tripod, which folds up and takes very little room in her camera bag. By bracing this little unit against a vertical wall or a flat horizontal surface, Mark can assure herself of camera support.

FILTERS

For most purposes, a photojournalist needs only three types of filters: *skylight* filters (primarily to eliminate the blueish cast that color films often show in outdoor shadows), *neutral density* filters

NEUTRAL DENSITY FILTERS

Density	Reduces Exposure by (f-stops)
0.10	⅓
0.20	⅔
0.30	1
0.40	1⅓
0.50	1⅔
0.60	2
0.70	2⅓
0.80	2⅔
0.90	3
1.00	3⅓

(used to slow down an exposure when shooting in bright light with fast films), and a *polarizing* filter (for penetrating haze or reducing hot reflections from water or glass, or to darken the sky in color photography without altering other colors).

Mark usually keeps skylight filters over all her lenses. They do not require any exposure compensation and their effect on black and white film is imperceptible. If anything, they slightly enhance contrast. For shooting color film under the hazy light conditions that Mark prefers, this filter eliminates the overall blue cast that is a common liability of such light. In addition, the skylight filter is, as Mark explains, "the ideal way to protect lenses. It's much cheaper to replace a scratched filter than to replace a scratched lens."

PHOTOGRAPHING PEOPLE

Mark and Leibovitz are concerned with current events and people who are newsworthy. Their themes might be as sweeping as war, love, or social change; or they might isolate a single individual or small group for scrutiny and, in this way, make some commentary about the human experience. It is basically incisive story-telling that separates the thoughtful photojournalist from the average newspaper photographer who often simply records an event or newsworthy person. The photojournalist does more than record. By careful scrutiny of the interaction between people, with a close-up look at faces, attire and body language, she interprets what she sees.

In a large sense, Mary Ellen Mark and Annie Leibovitz are journalistic portraitists. Their styles, however, are at distinctly opposite ends of the portrait spectrum.

While Mark's portraits are deceptive in their snapshot-like simplicity, Leibovitz's reflect dramatically the positive guiding hand of the photog-

rapher coaxing her subjects into stylized poses and expressions. And her choice of locations is usually more compatible with her personal vision of the subject than with any attempt to show a realistic environment. Bette Midler had never been in the bar where Leibovitz photographed her until the photographer took her there (pages 40-41). Art Garfunkel found himself standing in front of a fake sky backdrop (page 45). Even when the environs are significant—Eric Anderson was photographed at the Coffee Gallery in San Francisco, where he started his career as an entertainer (page 47), David Cassidy at his lush house (pages 52-55)—Leibovitz chose to ignore whatever statements might emerge from the inclusion of environmental detail. Instead, she isolated her subjects, making her pictures as clean-cut a personal interpretation as she made the series of Daniel Ellsberg turning full circle, apparently in limbo (pages 26-27), or Joe Dallesandro stripping to the waist to match his semi-nude child (page 29).

While other photographers seek anonymity, as does Mark, to make the portrait a one-to-one relationship between viewer and subject, Leibovitz believes that the photograph might as well acknowledge her presence and participation. In that sense she fits into the new journalism that denies the possibility of true "objectivity"; even the quietest fly on the wall changes the room in some way, and the photographer should acknowledge that her presence has some effect on the subject. Therefore, in one of her pictures in which surroundings play an important part—Ann Peebles huddled in the corner of a dressing room (pages 6-7)—Leibovitz had no reservations about showing her electronic flash reflected in the mirror. About another photo she recalls, "The picture of David Cassidy lying on the grass showed my foot

in the corner of the frame. I saw it in my viewfinder and didn't mind it at all. But when Rolling Stone decided to publish the shot, the art director had my foot airbrushed out." Did she ask to have it put back in? No; but she would not have asked to have it taken out, either.

Among the many techniques for photographing people, each photographer works out a method that suits his or her personal needs. Even if the main purpose of a picture is simply to preserve the likeness of someone close to you, you might consider including a background that is significant, a pose or situation that tells something about your subject, or a combination of both.

ANN PEEBLES
[pages 6-7]

This photograph was made in the rather dim dressing room of a Los Angeles nightclub. To overcome the low level of available illumination, Leibovitz chose to light the room with "bounce" from a portable strobe unit. Since the room was small, she knew that a single strobe was sufficient to cover the entire area, and elected to place the unit behind her, bouncing light from the pale ceiling to avoid the harsh effects of direct light on her subject. The problem she then confronted was how to determine the proper expo-

sure settings for her camera. Her solution—which is probably the simplest way to make exposure readings of electronic flash—was to use a special strobe meter capable of reading the extremely brief light output of an electronic flash unit. The type of meter which Leibovitz uses is connected directly to the strobe unit itself, and, when held close to the subject, can be used to fire the flash manually for a reading.

An alternate technique for photographers who do not have a strobe meter is simply to calculate the correct exposure on the basis of the flash unit's guide number (as assigned by the manufacturer for the particular film being used). When the strobe unit is pointed directly at the subject, these calculations are simply a matter of dividing the strobe's known "guide number" by the distance between the subject and the flash to determine the correct f/stop. In a case such as this, however, where the flash is not pointed directly at the subject but at a nearby reflecting surface, some compensation is necessary to prevent underexposure. The reflecting surface should be as white as possible if one is working with color film, since reflected tints adulterate the overall color of a photograph. The most reliable method is simply to divide the guide number in half and make the above exposure calculation on the basis of this new guide number. In this photo, for example, Leibovitz was using a portable strobe unit with a guide number of 240. Dividing that by two would give her 120; since the distance from her strobe to the ceiling and then to Peebles was 10 feet, dividing this new guide number by 10 would give her a correct aperture setting of f/12, approximately one-third of a stop less than f/11. In addition, if time permitted, she would have made several shots, bracketing aperture settings to insure correct exposure.

MICK JAGGER ONSTAGE
[Pages 18-19]

Photographing rock star Mick Jagger during a live performance presented Annie Leibovitz with two major problems. The first was determining the correct exposure for a subject who is, of necessity, a considerable distance from the photographer. Since Leibovitz uses a Nikon equipped with through-the lens metering, this problem was minimal. Her on-camera meter, in conjunction with the 180mm lens she had chosen to bring her subject "closer," provided correct exposure information effortlessly. If she had been forced to rely on a conventional handheld meter, her best option in such a case would have been to use a spotmeter, or to find some area nearby where the illumination level approximated the light falling on her subject. A reading made of this substitute area with a conventional meter, along with the extra precaution of bracketing exposures, would get around the inherent limitation of the handheld light meter in this situation.

The second technical problem was one of maintaining sharp focus on Jagger as he moved wildly around the stage. Focusing, of course, is always a critical consideration when dealing with a moving subject. But in this case, that problem was compounded first by the fact that Leibovitz was using a telephoto lens (which always requires rock-steadiness for acceptable sharpness) and second, that she was forced to shoot at a relatively large aperture setting (f/4, with Tri-X rated at ASA 800). Although this f/stop allowed her to use a fast shutter speed of 1/1000 second and

thus minimize the possibility of camera movement during exposure, the shallow depth of field at this setting made "following" her subject in sharp focus more than a little difficult. Rather than remaining stationary as the singer gyrated back and forth and trying to maintain focus by adjusting the lens barrel, Leibovitz used the easier technique of moving her body instead. As Jagger leaned forward towards her, she simply leaned backward, keeping—as much as possible—a constant distance between herself and her subject without adjusting the focus setting on the lens. When Jagger moved laterally across the stage, of course, she could not use this technique and had to follow-focus instead.

JAGGER LEAVING AIRPLANE
[pages 20-21]

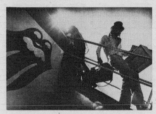

This dramatic rendition of Mick Jagger descending an airplane loading ramp demonstrates Leibovitz's successful solution to a common exposure problem—backlighting.

In this situation, she had two principal exposure options—either to base her exposure setting on the light *behind* her subject, or to base it on the shadow area of the singer as he came between her camera and the sun. By exposing for the shadows as she has done here, she retains adequate detail in the subject's features and achieves this bright, high-key picture of a moment in Jagger's frenetic life.

If she had exposed for the background illumination instead, the result would have been a simple silhouette of Jagger, with no detail in the

shadow area facing the camera. By taking the precaution of exposing for the shadows, she left herself the option of producing the silhouette later in the darkroom, if she wanted, by extending the printing exposure time and using a high-contrast paper when making her final enlargment.

LILY TOMLIN
[Page 44]

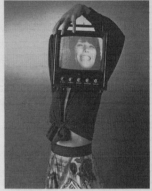

The principal problem posed by including a television image in a still photograph, such as this portrait of comedienne Lily Tomlin, is one of achieving correct lighting balance. A television monitor requires 1/30 second to construct a coherent image (because of the rate at which its internal electron gun scans the individual lines of the screen). To capture the entire image as it appears to the television viewer, therefore, the photographer must use a shutter speed of 1/30 second or less. With the shutter speed already predetermined, the exposure must then be calculated so that the aperture is consistent with that shutter speed. Leibovitz solved this problem in the following manner:

A video camera was trained on Tomlin, transmitting images of her face by closed circuit to the screen of the monitor hung in front of her. Keeping the lighting simple, Leibovitz positioned a floodlight to the left of her still camera, near the TV camera. She put a second flood to camera right but much farther away, to soften shadow areas. A baby spot

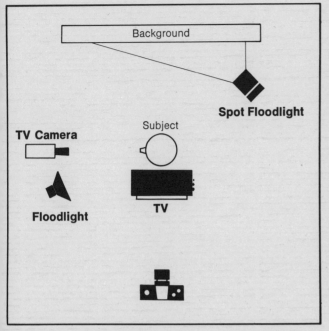

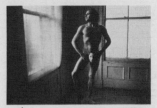

was pointed at the backdrop behind Tomlin's head to create a halo. Leibovitz then made an initial exposure reading of the screen, which indicated a working aperture of f/2 at the required 1/30 second shutter speed. Subsequent readings made from the subject's face and from the background, however, called for f/stop settings much smaller than the f/2 required by the screen. By carefully moving the light sources farther away from the subject and making some minor adjustments to the TV screen's brightness level, Leibovitz quickly balanced the illumination level on both

subject and background at her exposure of f/2.

She was particularly concerned with preventing light from either of these two sources from striking the television monitor screen, and chose tungsten lighting over strobe in this case to allow for careful previewing.

ART GARFUNKEL
[Page 45]

Lighting balance was again the major problem in this combination daylight and strobe shot of singer Art Garfunkel. In order to render the sunset background and the artificial sky backdrop simultaneously, Leibovitz first

made an exposure reading of the sunset. She then made a second reading with her strobe meter to determine the correct exposure for the foreground. By carefully altering the distance between the strobe and the subject, she insured that the exposure setting indicated for the foreground was the same as the setting indicated for the sunset. The principal hurdle here was the fact that her Nikon will only synchronize with an electronic flash unit at speeds of 1/60 second or

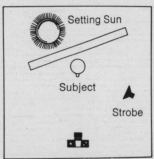

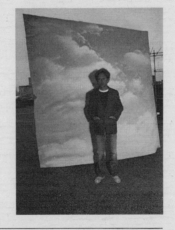

slower, making 1/60 second the necessary basis for her initial exposure reading of the sunset.

RALPH GIBSON NUDE
[pages 58-59]

To photograph her friend Ralph Gibson in the nude, Mary Ellen Mark decided on an indoor setting and natural light. The situation presented several problems. First, how was she to balance indoor light intensities with the daylight shining through the windows? Second, how was she to balance contrasts in the various areas of the picture while shooting, for dramatic effect, into her light source?

She chose a corner of Gibson's New York loft where windows not only cast light directly on the subject, but where off-white walls bounced light into shadow areas almost as efficiently as if she had used reflectors or a fill light. The effect was something like standing Gibson inside a tent.

She used daylight film even though the photograph was to be made indoors, because of course her light source was daylight. For drama, she exposed for highlights rather than shadows, in essence underexposing the picture, thus somewhat balancing the light coming from the window. The key to successful underexposure here is turning the subject slightly sideways so that his face is in the highlight area while his body becomes, in essence, a semi-silhouette.

Converted to black and white, the picture would not work as well, since various shades of greys tend to merge and lose the dimensionality that cool blues and warm flesh tones give it. What makes it interesting in color is that the gradations of blue in the windows recede,

CAMERA SETTINGS FOR PICTURES OF TV IMAGES

Film	Black-and-White Television Set		Color Television Set	
	Leaf-Type Shutter	Focal-Plane Shutter	Leaf-Type Shutter	Focal-Plane Shutter
VERICHROME Pan PLUS-X Pan	1/30 sec f/4	1/8 sec f/8	1/30 sec f/2.8	1/8 sec f/5.6
TRI-X Pan	1/30 sec f/5.6 ▲ 8	1/8 sec f/11 ▲ 16	1/30 sec f/4 ▲ 5.6	1/8 sec f/8 ▲ 11
KODACHROME-64 EKTACHROME-X KODACOLOR-X	1/8 sec f/2.8 or 1/15 sec f/2	1/8 sec f/2.8	1/4 sec f/2.8 or 1/8 sec f/2	1/4 sec f/2.8 or 1/8 sec f/2
High Speed EKTACHROME (Daylight)	1/15 sec f/2.8 ▲ 4	1/8 sec f/4 ▲ 5.6	1/8 sec f/2.8 ▲ 4	1/8 sec f/2.8 ▲ 4

as blues will, while the contrasting warmer tones of Gibson's skin make his body stand out in relief from the blue.

Mark's exposure reading was made with an incident light meter. She used Kodachrome II with a 35mm lens, 1/30 second at f/4.

WAC WITH CAMOUFLAGE
[Pages 68-69]

The use of fast shutter speeds is generally restricted to occasions when the subject is moving and the photographer wants to freeze the action. In making this portrait of a WAC under a bonnet of leaves for camouflage, Mark made a decision to use the fastest shutter speed her Leica M4 was capable of: 1/1000 second. The inevitable question would be, of course, "Why?" After all, the WAC is stationary, merely posing for the camera.

The purpose is strictly to control the ratio between shutter speed and aperture setting to obtain an exposure that makes the picture tell the story the photographer wants. The normal reading for this photograph (rating Tri-X film at ASA 400) would have been around 1/250 second at f/8. Mark recognized, however, that at f/8, the leaves in the background (which she wanted to complement the headdress) would be so sharp that they would blend with the outline of the camouflage. This, of course, is the intent of camouflage, but for the photograph it would have been too confusing. She therefore decided to decrease the depth of field of her lens by opening it up as much as possible. She decided to use the fastest shutter speed possible,

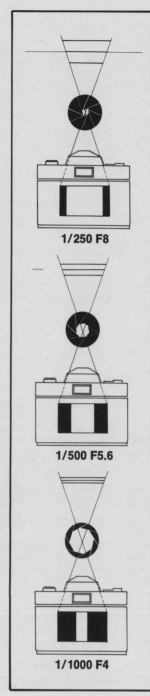

1/250 F8

1/500 F5.6

1/1000 F4

1/1000 second, which required an aperture of f/4. Even this, she felt, would make the background sharper than she would have liked. Therefore, she cut down her light two full stops more by attaching a 4X neutral density filter, which required her to open up the aperture to f/2 at the 1/1000 shutter speed. By manipulating whatever controls she could, she obtained the precise type of photograph she desired.

PORTRAIT OF CAROL
[Page 88]

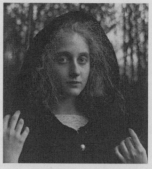

Reminiscent of a Botticelli painting, this portrait of actress Carol Kane was made during Mary Ellen Mark's coverage of the motion picture *Carnal Knowledge*. The photograph itself had nothing to do with the film, but was made on a day when there was nothing scheduled for Mark to photograph, so she decided to take pictures of Kane.

Possibly influenced by Kane's facial features, Mark had her bring along a hooded cape for the shooting. They walked out in the woods behind the film studio in Vancouver, British Columbia, to an area where the light was soft and diffused. In order to keep the background out of focus, Mark opened her lens to an aperture of f/2, and with the compensating shutter speed of 1/125 second, made this serene portrait on Ektachrome X film.

The photograph demonstrates how carefully Mark used the prevailing light. While the light itself was diffused by trees, it was sufficiently strong to give good modeling to the subject's facial contours. In addition, by paying attention to her subject's position, Mark obtained an almost perfect 45-degree angle to the light, an angle ideal for portraiture.

LENSES FOR 35mm CAMERAS
ANGLE OF VIEW — MINIMUM FOCUS DISTANCE

Focal Length Millimeters	Angle of View Degrees	Minimum Focus Inches-Feet
8mm	180°	12"
15mm	110°	12"
20mm	94°	12"
24mm	84°	12"
28mm	74°	12"
35mm	62°	12"
50mm	46°	24"
55mm	44°	24"
85mm	28°	3'
105mm	23°	3'6"
135mm	18°	5'
180mm	13°	6'
200mm	12°	7'
300mm	8°	13'
500mm	5°	13'
1000mm	2°	25'

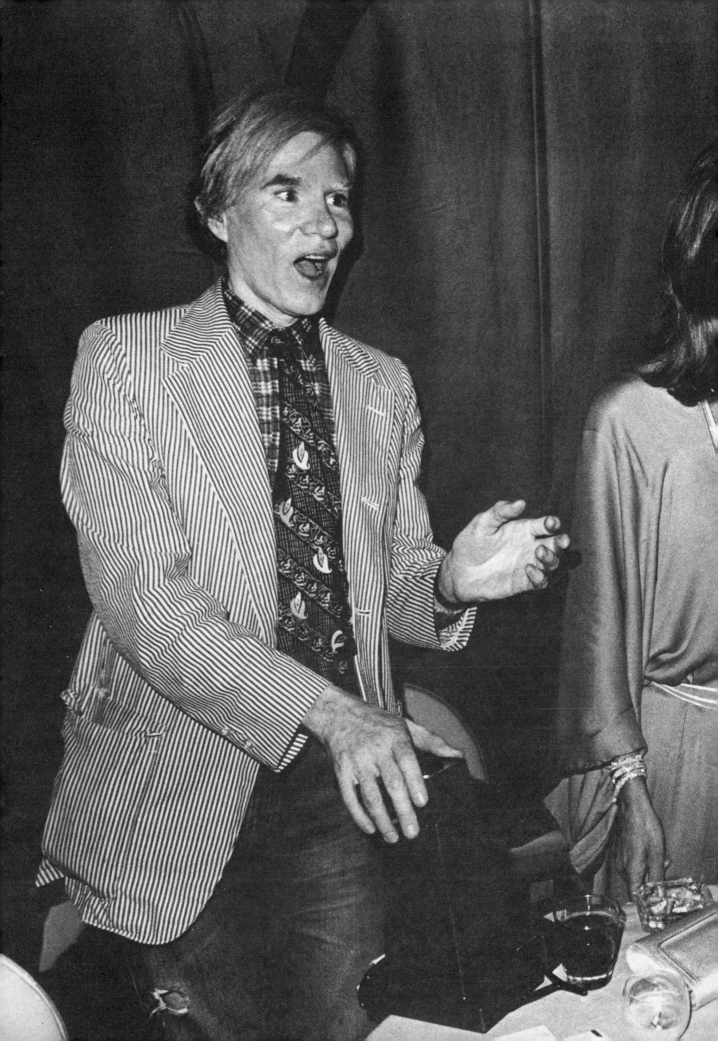